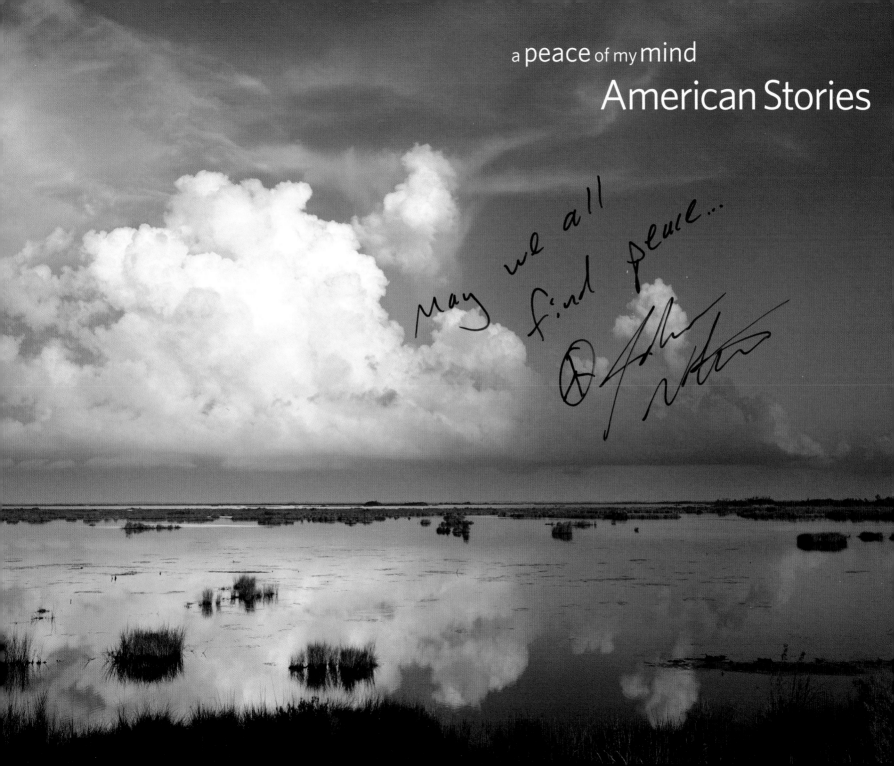

a peace of my mind
American Stories

May we all
find peace...

a peace of my

of my

exploring the meaning of peace

mind

one story at a time

American Stories

for all who tend to the light of hope

Designed by Barbara Koster,
Barbara Koster Design

Maps by Patti Isaacs, 45th Parallel
Maps and Infographics

Peace candles photograph,
page 2, by Brenna Noltner

Special thanks to Donnie Phillips
for permission to reprint his poem,
Blind, page 34, and to Benita Alioth
for her poem, *Inside Out*, page 89.

Typefaces are Adobe Garamond
and Hoefler & Co. Whitney

Printed by Sexton Printing,
St. Paul, Minnesota, USA

www.apeaceofmymind.net
www.noltner.com

ISBN 978-0-692-76084-0

contents

9 foreword
*by Terri Lee Freeman, President,
National Civil Rights Museum*

10 introduction
by John Noltner

14 stories of peace
many voices

138 index

142 discussion questions

143 about this book

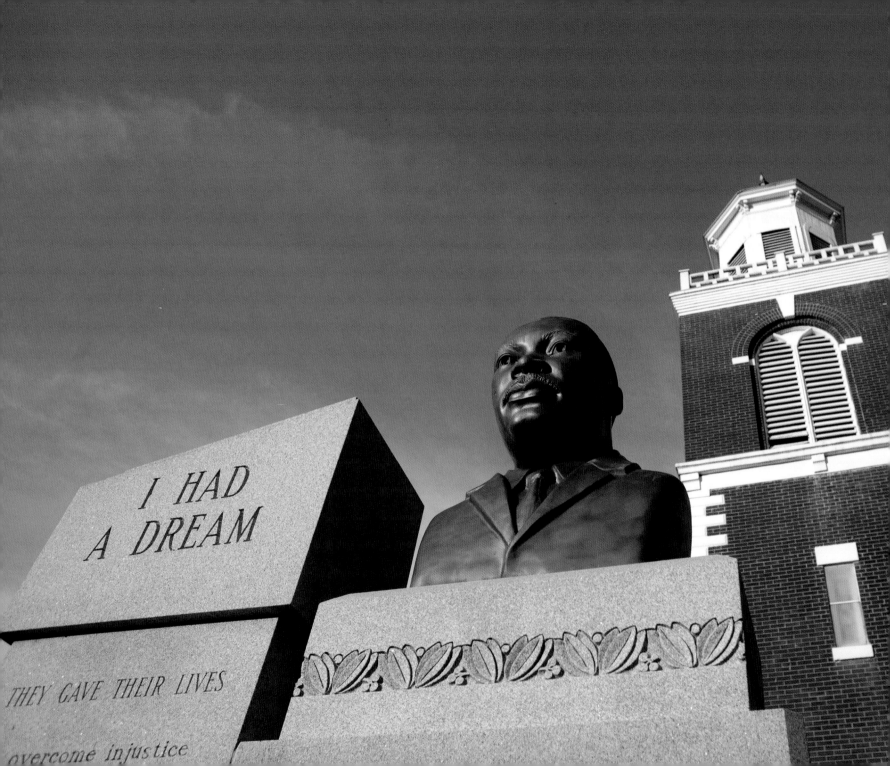

We are living in perilous times. Times when too many have become comfortable with hateful rhetoric, demonizing and marginalizing others. Times when tragic, senseless violence is instantly available to us through social media. Times when conflict is rooted in fear, hate, and a lack of understanding. Our communities and our nation have a heart problem. We have not yet learned that love is far more powerful than hate.

We are nearly 50 years past the assassination of Dr. Martin Luther King Jr., who dedicated his life to peace and justice for all people. The civil rights we document at the National Civil Rights Museum focus on the racial rights of his era, but the civil rights of today include race, gender, faith, sexual orientation, and more. Ultimately, as we look at civil and human rights, it's the humanity that we seek.

Today we are a far more diverse society than we were in the 1960s, yet our tolerance for diversity, and more importantly, inclusion appears to be decreasing. We must find ways to look each other in the eye, and seek humanity. We must look beyond the profiles—skin color, blue uniform, sexual orientation, religious affiliation—and recognize our human connection. We must come to terms with our differences and recognize that those differences should enhance our connections rather than stifle them. We must move beyond tolerance to genuine concern and care for all if we are to find peace.

In 2016, we lost a great voice for the human spirit and for peace, Elie Weisel. In his words, "At critical times, at moments of peril, no one has the right to abstain, to be prudent. When the life or death or simply the well-being of a community is at stake, neutrality is criminal, for it aids and abets the oppressor and not his victim."

With *A Peace of My Mind: American Stories,* John Noltner responds to an increasingly divisive world with humanity. Every person has a story. Every individual wants to be heard. In these pages you will find a beautiful collection of photographs and narratives from the American experience built around the desire for peaceful solutions and outcomes to societal and personal strife.

These portraits of everyday people with stories that we can relate to are incredibly compelling and pull you in to the individual's situation and circumstance. This work will tug at your heart and your sense of humanity. Some of the stories will make you nod your head in agreement. Others will cause you to shake your head in shame.

A Peace of My Mind will make you question why violence and hate remain so prevalent in our society. It will make you consider your role in helping heal the wounds of history and bridge the differences that are far too often given more weight than is appropriate. It's difficult to digest this work and remain indifferent.

As the baton has been passed from the icons of yesterday to each of us, we must ask ourselves, how will we respond? *A Peace of My Mind* is an encouraging stimulus to action.

Dr. King once said, "Darkness cannot drive out darkness; only light can do that. Hate cannot drive out hate; only love can do that."

Let the stories in these pages reveal the promise and value in each of us.

—Terri Lee Freeman, President
National Civil Rights Museum

introduction

This has been a journey of discovery.

Frustrated with the way the world encourages us to focus on what can separate us, I set out to use my photography and storytelling to explore the common humanity that connects us.

Over the span of three years, I drove 40,000 miles across the United States, asking people the question, "What does peace mean to you?"

It's a simple question, but one that quickly gets to the core of who we are as human beings and what we value as a society. It opens the door to conversations about our greatest hopes and deepest fears. It leads to dialog about conflict resolution, civic responsibility, and social change. It addresses issues of race, gender, faith, equity, and justice.

This book is a snapshot of a moment in time. Many of these interviews were planned in advance. I connected with civic groups, non-profits, and friends across the country to recommend subjects and make introductions. Other encounters were more serendipitous, crossing paths with interesting people on the road and inviting them into the project. In all cases, we sat down for an hour-long recorded interview, and then we made a portrait.

The results are shared here, as podcasts at www.apeaceofmymind.net, and in a traveling exhibit.

People change. We live in a fluid world, and perhaps the people in this book would offer different answers if they were interviewed again today, based on new experiences or new information.

People are complicated. In our modern news cycle, individuals are dissected and discarded based on whatever character flaws can be uncovered. I'm not sure many of us could stand up to the scrutiny. I'm certain I could not.

I'm sure we could find the flaws in one another if that was our focus. Certainly there are problems in the world that could put us at odds and turn us into fast enemies. But what if we shifted that focus?

What if we spent our time looking for the examples of what worked well in the world? What if we emphasized the beauty and good in one another? What if we celebrated examples of positive change, and held that up as a model for how to move forward?

A Peace of My Mind is a project about listening. We are quick to hear a few words, and rush to judgment. We encounter certain trigger words, our minds scramble to fill in all the blanks and suddenly we know all we need to know about the person. In the process we miss out on the rich and varied nuances that can build understanding. What if we simply took the time to listen?

I encourage you to use these stories for reflection, understanding, and dialog. You won't find any one definition of peace, you'll find many. You'll find beautiful examples of forgiveness, grace and transformation. You'll find stories of people who work for positive change every day. More than anything, you'll find stories of hope.

In a challenging world, there is a better way. May these stories of hope guide us.

May we all find peace.

—John Noltner
A Peace Of My Mind

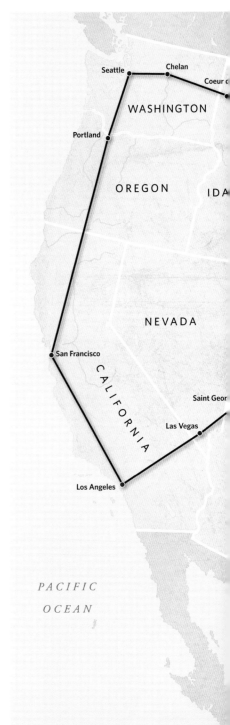

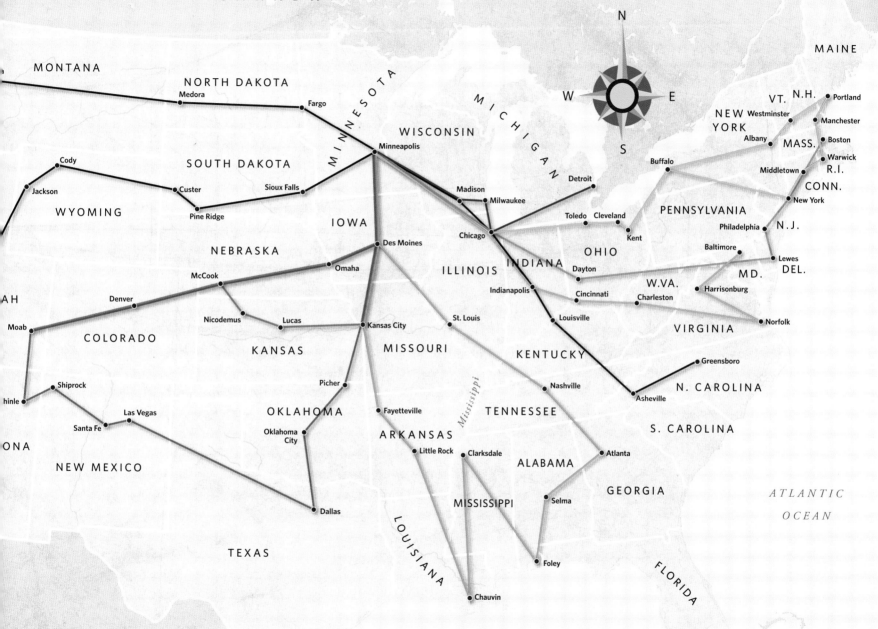

the atlantic states

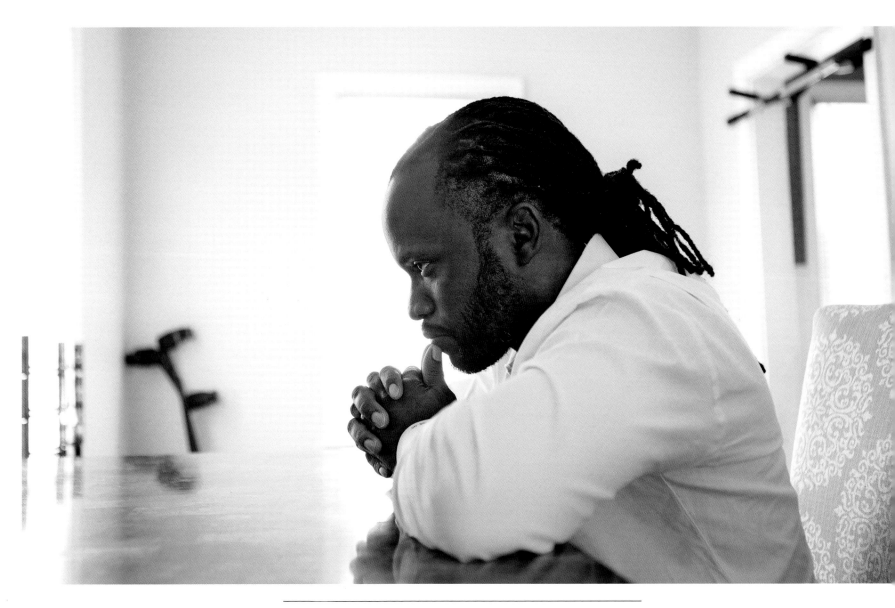

"*I want to love those who haven't shown me love.
I want to be kind to those who may not
deserve my kindness.*"

Hashim Garrett

Hashim Garrett grew up in Brooklyn, New York. As a young boy, he changed schools and was picked on and bullied. He realized that he could avoid the torment if he befriended his tormentors, and he eventually joined a gang. There was something powerful about having others fear him for a change. He said that when he was good, nobody noticed him, but when he was bad, everybody knew his name.

At 15, Hashim was shot and paralyzed from the waist down. He says nothing but tragedy could have broken the spell of being bad. As he lay on the ground wondering if he would live or die, his eyes were opened, and he decided to change.

Today Hashim is married and has two children. He works with high school students to reduce violence. Hashim has forgiven his shooter because he realizes that the shooter was caught up in the same series of bad choices that Hashim had experienced.

HASHIM GARRETT
ORANGE
NEW JERSEY

THE ANGER WAS A WAY to cope with fear. I got tired of being afraid. I decided to hang out with the kids who picked on me. I wound up joining a gang. I was about 12 or 13 when I got involved with them.

It wasn't like one day I became this terrible kid. It was a slow process. Sixth grade, cutting school a little bit. Seventh grade, cutting school and smoking. Eighth grade, jumping people. Ninth grade, getting arrested. By the time I was 15, I was carrying guns. I was shooting people. I didn't want to go to school. I wanted everybody in Brooklyn to know who I was.

I enjoyed not being that scared kid anymore. I enjoyed instilling fear into people. It just morphed into wanting to hurt people and not caring if I lived or died.

My life changed on Monday, May 7, 1990, at 7:30 in the evening. My mom kept telling me, "Your friends are not good friends." I knew they weren't. I don't know if they wanted me to get killed, but I know they wanted something bad to happen to me. We weren't seeing eye-to-eye. They wanted me to get shot. They were trying to teach me a lesson.

I remember yelling, "Yo, I got shot. I got hit." I was on the ground. I was all by myself. I remember being afraid because I couldn't move. I couldn't feel my legs. I hadn't felt fear like that in my life. As soon as the bullets hit me, that tough kid vanished. My anger at the world vanished in a blink of an eye.

There's no glory in getting paralyzed. Nobody prepared me for this part. I don't want tough. I want to walk. I don't want tough. I want to live. Getting shot and being paralyzed was humbling. I'm grateful for the experience. I wouldn't be the man I am today had that not occurred.

I find my peace by giving it away, by making people feel loved, by thinking of others first. My peace comes from helping. My peace comes from giving.

We're all imperfect. I want people to love me with my flaws, so I have to love them with their flaws.

We all struggle. My issues may be a little bit more extreme than yours, but at the end of the day, we're all human beings. We're all going through the same thing, drinking the same water, breathing the same air. We came into this world the same way. My problem is your problem.

I have to hold myself accountable at some point. I can't say, "You are the reason why my situation is so dire." Yeah, there are mechanisms in place, but I have to hold myself accountable. My success and my happiness cannot depend on how you treat me.

Why are you doing drugs? Why are you smoking? Why are you dropping out of school? Why are you killing? Why are you not being faithful? Understand the problem. Understand what needs to be addressed.

Where are the values? Where are the moral tenets that we follow? Hopefully, spirituality will be our compass and our guide. We have to treat people the way we want to be treated. We have to forgive because we want to be forgiven. We have to love because we want to be loved. It's so basic. It's so simple. We human beings are the ones that make it complex.

LAURA PATEY
MIDDLETOWN
CONNECTICUT

Laura Patey has been with her partner, Leigh, for 30 years. They have been married since 2004. Together, they adopted two adolescent boys out of the foster care system who are now in their 20s. She has always been interested in advocating for the marginalized in society. She recalls her own struggles of not quite fitting in as she was growing up, and she believes that experience has led her to be a protector of and an advocate for the underdog.

I AM ONE OF SIX KIDS. I remember going home for the holidays and my siblings were talking about their significant others. I just talked about work because I didn't feel like I could talk about who I was. It took a long time. I didn't come out until I was in my early 30s.

It's been a transformative process for me and for others in my family. It's all relational. When we connect with others who are what we perceive as different from ourselves, we realize that there is far more commonality than there is difference. That's what I am always looking to do. When I advocate for folks who are marginalized, it's a matter of making sure they know that they're valued and loved. That connectedness gives them a sense of self, and allows them to make other connections. I think that's our purpose on Earth.

My kids bounced around in foster care for years. They had not only been removed from their birth families and lost all of those connections, but they had both been adopted and the adoptions were disrupted. That's the word they use. Jesse had been with his adoptive mom for four years and one weekend she dropped him off at respite care and never came back.

Kids who have been in foster care have had so much pain and loss in their lives that they have a hard time making connections. Working through the pain of kids who have experienced disrupted connections and teaching them that they are valued and loved is a critical element of what we do.

We discovered that kids pick on kids for any number of reasons. We armed our kids for the fact that not everyone was going to value our family. That was okay as long as we surrounded ourselves with people who did: our church community, our friends, and others. We practiced making statements. When somebody would make fun of Jesse on the football field and say something about his two moms, he would say, "Pick a real issue." That was the line. "So pick a real issue."

When Alex was in school, one of the administrators said, "Well, you know, *these kids.*" And I was like, "Which kids? Are you talking about kids who have been in foster care? Are you talking about kids with two moms? Latino kids? Which *'these' kids* are you talking about? What are your expectations? Do you see this kid as a human being? As someone who has unbelievable skills and assets? Or do you just see them as a marginalized kid who is OK to throw away?"

That attitude kills their soul and their spirit. We talk a lot about embracing who you are and what it brings to your life. For me, it's not about having people tolerate or accept you, it's about embracing your identity.

Peace is a state of mind. It is a very personal thing yet we experience it only in relation to others. It's about human connectedness. Peace is this inner sense of well-being and knowing that you are valued as an individual and that you are loved.

In our church we have older folks who never knew that they knew anyone who was gay or lesbian. Then they knew me and they knew Leigh. Then they saw us with our son Jesse. Then they saw Alex come home to us and the love that was part of our family. Those things break down barriers. They weren't threatened by what they saw. They saw two parents caring for their kids, wanting them to have a sound spiritual base, and wanting them to be part of a community. That's not at all threatening. It's getting to know people and people getting to know you.

Peace is attainable if people can be vulnerable and be willing to sit with somebody else's vulnerabilities. That's how we get to a place where we can diminish fear and anxiety and ask, "What is it that we can do together more powerfully than either of us can do in isolation?"

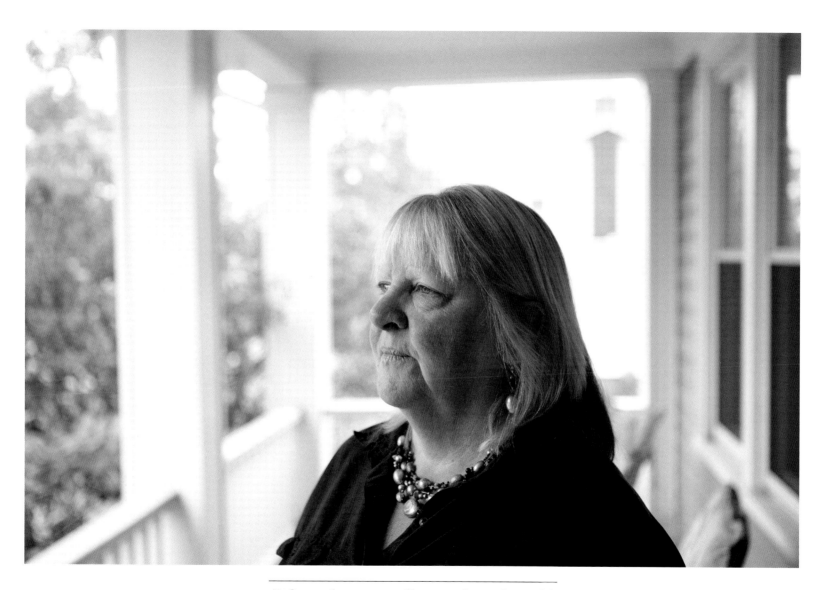

"If people were willing to be vulnerable
and sit with someone else while they are exposing
their own vulnerabilities, I think that we can then
really connect on a very deep level."

CANADA

MAINE

VT.

N.H. ● Orr's Island

ATLANTIC OCEAN

CHUCK RICKTER

ORR'S ISLAND
MAINE

Chuck Rickter is a lobsterman from Orr's Island, Maine. Although he has traveled the world, he has lived his entire life in the same small fishing community. He says life on the water is hard, unpredictable, dangerous, and tiring, but there is nothing he would rather do.

He appreciates living in a small community where "everybody's got your back," and speaks of the challenges when outsiders come in and try to change things that they don't understand.

Chuck's recalls a fundraiser for a local school that found "people from all walks of life coming together for a common good." To him, that is peace.

I HAVEN'T ALWAYS BEEN THE CALMEST, most peaceful person in the world. There was a time in my life where I was quick to rage. I've worked hard to get beyond that. Me and my youngest daughter had it out one time where we were just screaming at each other, and I had to leave. That was my a-ha moment. It's either I change this or I'm going to be by myself, without my kids, without my wife. And she'll probably get the dogs.

I'm not ashamed to say I got help. My life has gotten better since that point. My relationship with my daughters, my wife, and with the people around me has gotten better. There are some people who have left my life since that happened, because I figured out they aren't what's best for me as I try to lead a peaceful life. I'll miss them, but I don't want to be around people that hate everything because I no longer hate everything.

Sometimes there are things that you can't do for yourself. You need somebody to help you, and there's nothing wrong with that. My family and my friends know what I've been through. They love me for who I am now. They loved me for who I was then.

A day lobstering is getting up in the morning before sunrise, seeing what the weather's like. Then you go and get your boat and get your bait for the day. You put your head down and start hauling.

Some days you do good, some days you don't.

I'm part of this community. The only way in my mind that you can work on peace is to be a good person to the people around you and help when you can.

It doesn't matter what other people believe, as long as they're going in that same direction, trying to help you help them help somebody else. We're all in this together.

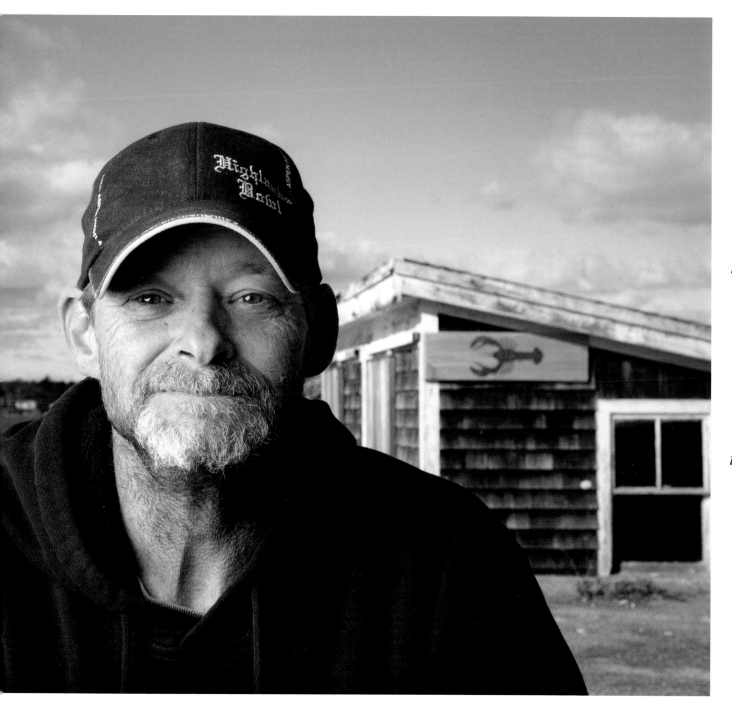

"I've learned through counseling that if something upsets you, you don't count from 10 to 1 because 10 to 1 is countdown to liftoff. You count from 1 to 10."

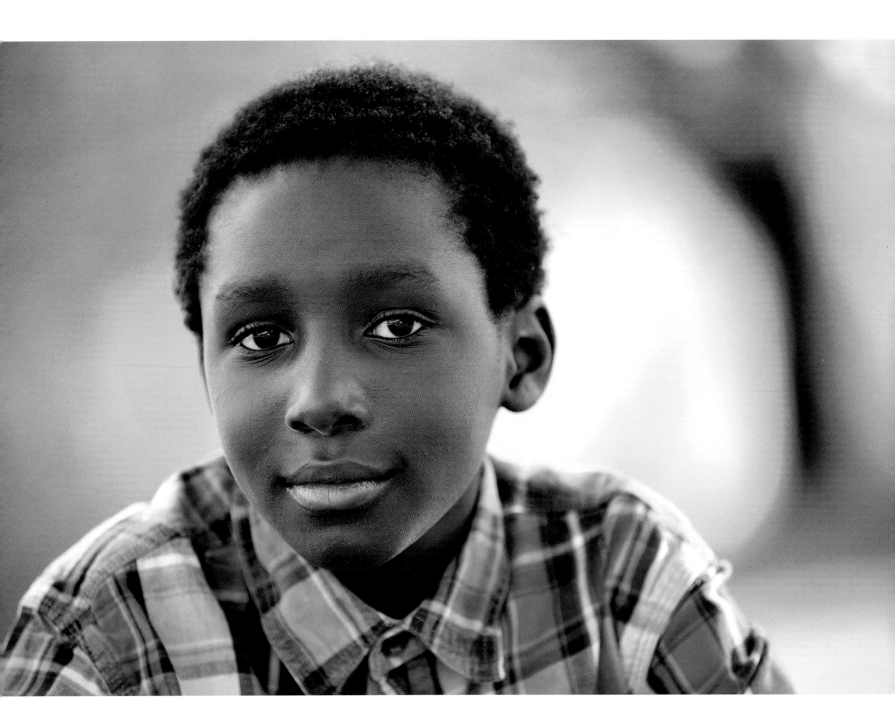

Alex Lowe is a fifth grade student at Kurn Hattin Homes, a Vermont residential school designed to offer kids "a secure and supportive haven during a troubled period in their families' lives." Alex's favorite animal is the great white shark and he plans to become a marine biologist.

BRIAN WAS IN MY COTTAGE last year and every time I was down, he would pick me back up. He would be nice to me and play with me, and when everybody else didn't want to do the things I wanted to do, he would come and comfort me. It made me feel great because it means I actually have someone who I can trust.

I guess that peace means that everybody gets along, everybody's actually bonding with each other, people are there for each other, and they make the world a better place.

If someone's being mean to me, I'll just walk away or ignore them. The fact is they're just trying to make you miserable like they are. When I got here, Rudy was my best friend. He was always having a great day, always making everyone happy. When I wasn't happy, I guess I tried to make his day miserable, too. He would be playing with Legos and I would come and smash them all away.

At first, it made me kind of feel good, but after it was done, I felt even more miserable because I just wrecked something someone made. I know I wouldn't like that if someone did that to me. If you see someone being mean to other people, try to stick up for that person.

Mostly, when I'm having a bad day, I start to write in my journal because that's one way that I get my feelings out. My mother told me that you don't always have to bring your anger out, and when you do, bring it out on paper.

It's hard for me to multitask. The houseparent will be talking to me, and my friends will be talking to me and I'll get in trouble with the houseparent. I'll get extra chores and my friends won't talk to me and it's just overwhelming. I tell them, "I'm really sorry that I wasn't listening to you. It's just that there are things that I have to do other than just hanging out with you guys. I have responsibilities."

My responsibilities are chores. We have a limited amount of time to get our chores done each day. My chores right now would be to clean the kitchen and the office. I have to wash the dishes, then I have to get the mop bucket and fill that up and let everybody mop, and then dump the mop bucket outside.

Responsibilities get us ready for the big world. It will be hard not having an adult there to tell you what you need to get done, and then you'll get sidetracked. You won't know what to do, and it will be puzzling.

Sometimes I feel as if I'm the only one that cares about things. I'll be one of those people who are doing things while other people are just sitting back and relaxing. I'll be changing the world and I'll be world-famous while they're just sitting on a couch watching TV all day.

I don't know how I'm going to get them to care. I haven't gotten that far yet, but I think being an example is a great idea. If I show them that I can get along with people, maybe they'll follow in my footsteps.

ALEX LOWE
WESTMINSTER VERMONT

"When I think of peace, I think of people shaking hands on the street and picking them up when they feel down."

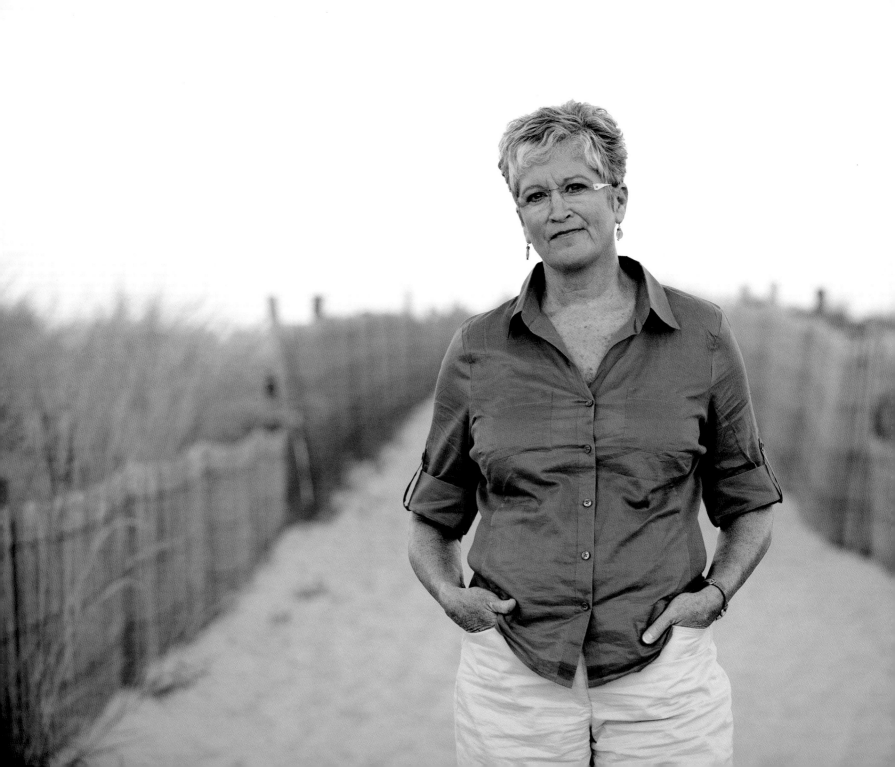

Kim Book's 17-year-old daughter, Nicole, was murdered in 1995. A year later, at the trial, she forgave Lavon, the young man who had killed Nicole, and that act of forgiveness opened a door to peace. Several years later, Kim founded Victims' Voices Heard, a restorative justice program in Delaware that brings victims and offenders together in an effort to promote healing for all parties.

L AVON WAS FOUND GUILTY of second-degree murder and is serving a 38-year sentence. I was told I could make a victim's impact statement, that I could address the judge and the court, but that I could not speak to Lavon. I came to the podium and began reading what I had typed. He was sitting right next to me, so I turned and told him that he had become a part of my life forever, that every day I was going to think about Nicole and every day I was going to think about him. I actually turned and was looking in his face speaking to him.

His face started softening; he was looking at me in disbelief. I told him that I hoped he would turn his life around someday, that I wanted good things for him. I walked out of the courtroom and felt like I had taken off a huge fur coat because I realized I had forgiven him. That was the most incredible moment for me. This is where peace comes from: forgiveness. Forgiving Lavon set me free. It was the key that unlocked the door that allows me to do everything I do today.

The day Lavon murdered Nicole, it was like he moved into my home. He chose to be a part of my life that day and I had to choose how I was going to live with him. Am I going to be angry every day or am I going to move forward? Am I going to do something positive?

Restorative justice is not about forgiveness, but I can tell you that there's a huge difference in those people who forgive and those who don't forgive. I see so much peace in those who have forgiven and I see the ones who have not forgiven still struggling.

Peace is tied to forgiveness for me. My forgiveness of Lavon was not for him, it was for me so I can move forward. If I was still waiting for him to take responsibility, for him to have remorse, I would be stuck forever. I'd be struggling every single day. I surrendered, I forgave, and then I had peace.

My purpose is to work with victims and offenders in a way that I hope will bring both parties peace. When they have peace, I feel at peace.

My father died nine months after he was diagnosed with AIDS. My parents never talked about the fact that my father was gay. As he was dying, he became semi-comatose. My mother had rheumatoid arthritis and she was crippled, so I was in their home, trying to take care of them. My father just kept repeating, "Forgive me, forgive me, forgive me." My mother got out of her chair and walked over to sit on his bed. She put her hand on him and said, "You don't need to say that anymore. You know you are forgiven." So I had incredible witnesses of peace and forgiveness in my life. Who was to know that I was going to need that example one day in my life?

KIM BOOK
LEWES
DELAWARE

"I have never been angry with Lavon and I can't explain that to you except to tell you that the day Nicole was murdered, I surrendered my life and said, 'God, you've gotta take this.' "

MATT MEYER

**BROOKLYN
NEW YORK**

*"Dr. King
talked in the
last years of his life
about the need
for a true
revolution against
militarism, racism,
and materialism.
That call has not
been fully
embraced."*

Matt Meyer is a teacher, author, and peace activist who was born and raised in Brooklyn, New York. He is a longtime member of the War Resisters League and was founding chair of the Peace and Justice Studies Association.

By studying activism around the world, Matt recognizes that nonviolent tactics can be effective for making revolutionary change. Matt views the status quo as unjust and believes that an international movement of radical social change is required to create lasting peace in the world.

IT'S A TRUE REVOLUTION of values building a beloved community that can resist militarism, materialism, and racism. Is that an ideal or is it an attainable goal? I think it's a process. You can never really get it completely. There'll always be injustice and repression among people who are and always have been different. I think that the global movement for peace and justice is just beginning to understand how to walk together and how to work together. So figuring out how to do something as complicated as defend or eliminate borders? That's stage two. We're not there yet.

I think powerful nations often produce activists who mimic some of the activities of the powerful. So it's very easy for U.S. activists to go around the world acting like we have all the knowledge because we have lots of the resources. Two or three of us could go to Chad and have a tremendous effect based just on our ability to travel and to sound very clever indeed. But I doubt we have any idea what Chad needs.

When I hear the word *peace*, I think of the word *justice*. When I hear the word *peace*, I think of the word *revolution*. When I hear the word *peace*, I think of a certain level of harmony through vigorous, rigorous confrontation, through revolutionary honesty, through unity in diversity. Peace is complicated. It seems simple—nice doves flying around—but without those other justice-related links, peace is nothing more than a utopian greeting card.

Revolution has gotten a bad rap, mainly because revolution hasn't often brought about justice, freedom, harmony, and peace. But to me, a radical critique suggests that the state of the world now is unjust and needs a complete turning.

Now, that doesn't mean a communist revolution. It doesn't mean a socialist revolution or an anarchist revolution. To me, the history of late–20th century revolutions is a history of glorious experiments, most of them failed. But they failed in the way that Christianity has failed, right? Has anyone really tried it? It's not that the teachings of Jesus of Nazareth were bad, it's what those guys who've tried to actualize his teachings have done with it.

Revolution has been tried and there have been great failings, because of the almost impossible expectations that when we achieve freedom, everything will be better. Sexism, racism, and all inequalities will be gone! Well that is unrealistic. That is an immature analysis of what revolutions have been and could be. But that doesn't mean we give up.

It doesn't mean the status quo is OK or that mere reform is a bad thing. Ninety-five percent of my life has been based in reform movements and that's cool. They're pieces of the pie. They're part of the process. But I use the word *revolution* intentionally because I believe the status quo is fundamentally unjust. I believe that a more complete, radical change is necessary structurally, institutionally, and personally in order to bring about peace.

Very few people would disagree that we have a world that's more at war than at peace. So to make peace out of war, you need to revolve the situation. You need to make fundamental change. You're not going to bring about peace by eliminating a weapons system, by ending that war, or by getting independence in a country. You need an international movement of radical social change.

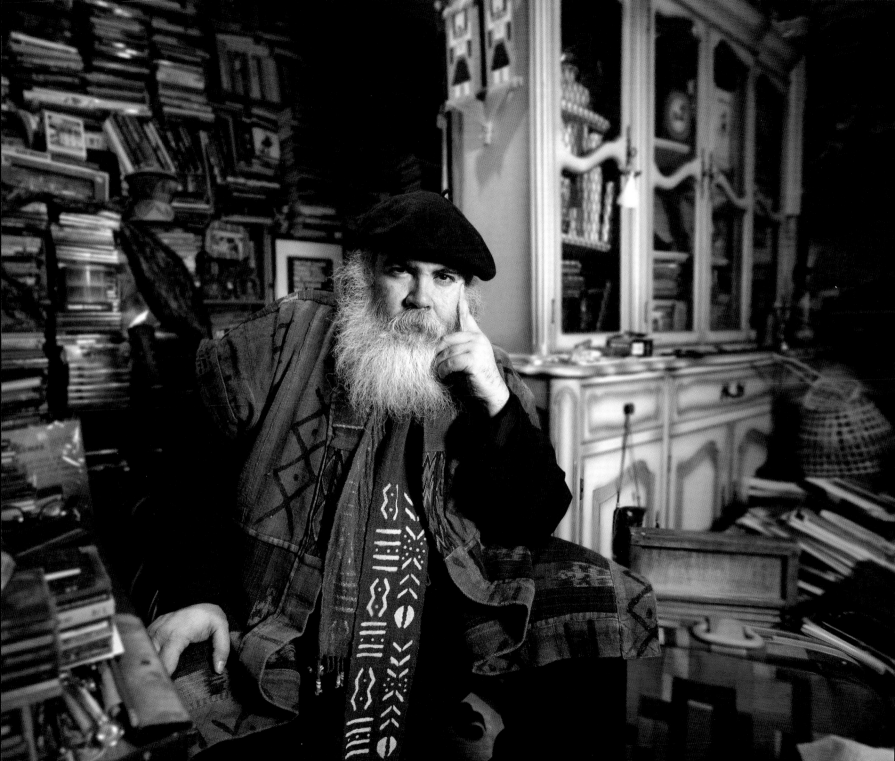

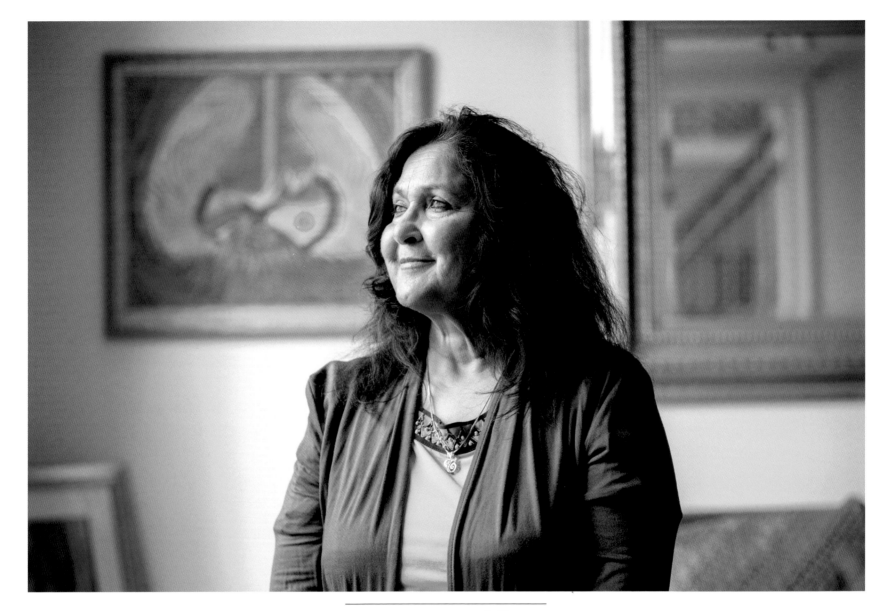

"*How is our pain different?*
How is your pain superior to my pain?"

Talat Hamdani is a Pakistani immigrant who moved to the United States in 1979. On September 11, 2001, her son Salman who was an NYPD cadet and an EMT, didn't come home. As the hours turned into days, Talat searched for Salman in the hospitals and morgues, but found no sign of her son.

As time went on, questions arose as to whether Salman was somehow involved in the attacks due to his Muslim faith. Talat faced not only the loss of her son, but the public assault of his character. She wondered if Salam were dead or detained.

Six months after the attacks, Salman's remains were found at Ground Zero with an EMT bag by his side. He had gone to the towers to help and gave his life trying to save others.

W HEN SALMAN was in the fourth grade, I sent him to a Catholic school. My parents sent us to parochial school in Pakistan for discipline and structure. I did the same. I told the principal that my kids will not go to church. One day he comes home and says, "I don't want to go to school any more mama." I said why? "Other kids don't like me. They say, you're not a Catholic. Why are you coming here?" I went to the principal and said, "Sister Maria, Salman doesn't want to come to school anymore because the kids are bothering him." She said, "I know, because when they go to church, he sits in the office and does service for 40 minutes. Don't worry, Mrs. Hamdani, I'll take care of it."

A couple of days later he comes home and says, "I need a copy of the Koran to bring it to school. Our social studies teacher told the whole class to bring in their book of faith." After that, there were no complaints. That is what this country needs: education of other faiths and tolerance and diversity.

Until and unless you're exposed to something, it's just a concept or just a name without a face. Since 9/11, Islam is being represented by terrorists. ISIS and ISIL are conducting in a very un-Islamic fashion in the name of Islam, and that is the image people have of Muslims. If it was any other faith or group and if I did not have any Christian or Jewish friends, I would fear them also. It's natural.

Salman got his diversity and tolerance education in the fourth grade. The country needs it now.

My objective is to show the American people—especially the non-Muslims—the face of a Muslim who died that day, show them that his family suffers the same pain as anyone else. Just because we are of a different faith doesn't mean that the pain is to a lesser degree, or that we don't miss our child, or that we are insensitive, or that we are cruel. No, you cut, we bleed. A loss is a loss. We are just like you and you are just like us.

I don't believe in revenge. You don't gain anything. Revenge destroys you.

They say revenge is for the Lord, but growing up, I was very angry at my friends one day. I was eight years old. My grandmother said, "Come here, what's happening?" I said, "I'm very upset at them and they said this and that," and I'm just blasting them. We don't curse, it was forbidden. She said, "OK, I'll tell you the best badwal that you can wish someone bad." (It's called a badwal in our Urdu language—like bad words.) I said, "Yeah, what is it?" She said, "You say 'may God bless you with better insight.' "

That had a good impact on my psychology. I don't believe in revenge. I just say, "May God bless you and give you peace." Why should I destroy my peace and my harmony by trying to connive and get even with them? Let them deal with God. I want to keep my peace.

We are made by the same creator. If you want to be happy and find peace, don't go toward revenge. Go toward positivity and build bridges with whoever you have a difference with.

N. Y. MASS.

CONN. R. I.

● Lake Grove

ATLANTIC OCEAN

TALAT HAMDANI
LAKE GROVE
NEW YORK

TYRONE WERTS
PHILADELPHIA
PENNSYLVANIA

Tyrone Werts

Tyrone Werts served nearly 37 years of a life sentence in Pennsylvania's Graterford prison after being convicted of second-degree murder. His sentence was commuted in 2010 and he was released on March 14, 2011. In prison, Tyrone was shown compassion by people who saw promise in him, which set him on a transformational path and eventually led him to become the person his mother and father had raised him to be.

W HEN I FIRST went into Graterford I was 23 years old, cocky, arrogant, bitter and angry. I was a self-destructive young man. Within six months, I transformed into the person my mother and father raised me to be. I went to school and got involved in great programs. It was important to me that I leave a legacy. I wanted my daughter and siblings to know that although I was in prison, I was a good person.

When you first go to prison they do an assessment. You have to take tests. Mr. Bello was a counselor at Graterford prison and an ABE teacher—that's Adult Basic Education. He was going over my assessment and explaining to me that I was reading at a second-grade level. My math skill was third grade. My comprehension was really low. I thought I was dumb anyhow, you know?

Education had no value to me. When I was in elementary school, my teacher kind of put into me that I was dumb, that I couldn't learn. And so, in my mind, I'm telling myself "Well, if I'm dumb and I can't learn, why should I even go to school?" So Mr. Bello is explaining all this to me about my test scores and he says, "What's interesting is that although your test scores are low, your IQ is above average, so you can do this stuff. You're just not applying yourself."

Normally, when you go to prison, you're just a statistic. Everything is a formality. But it was an act of compassion for this guy to take a personal interest in me and put me in that ABE class, because that was the beginning of my transformational road.

And then, I had an epiphany. It just hit me like a ton of bricks. I remembered the day I got sentenced and all the wailing, crying, and yelling behind me from my wife, daughter, sisters, and friends. Across on the prosecution's side, the victim's family was crying and weeping. It didn't register to me on the day I got sentenced, but one day in my cell, I thought about it and said, "Wow. All this time I was focused on me." And it hit me—all this pain that I caused my family and the victim's family. All that anger and resentfulness that I was carrying, it was weighing me down.

And in that moment, I started this process of reflection, saying, "Man, I got to take responsibility for my life." I mean, I was willing to take responsibility for my crime, but more importantly, I had to take responsibility for my *life* and the direction it was going to take and how I was going to make this up to my family and the victim's family.

In light of the fact that I was heavily involved in a lot of destructive, violent things, peace means being in harmony with people around you and with your environment. It means looking forward instead of looking backward.

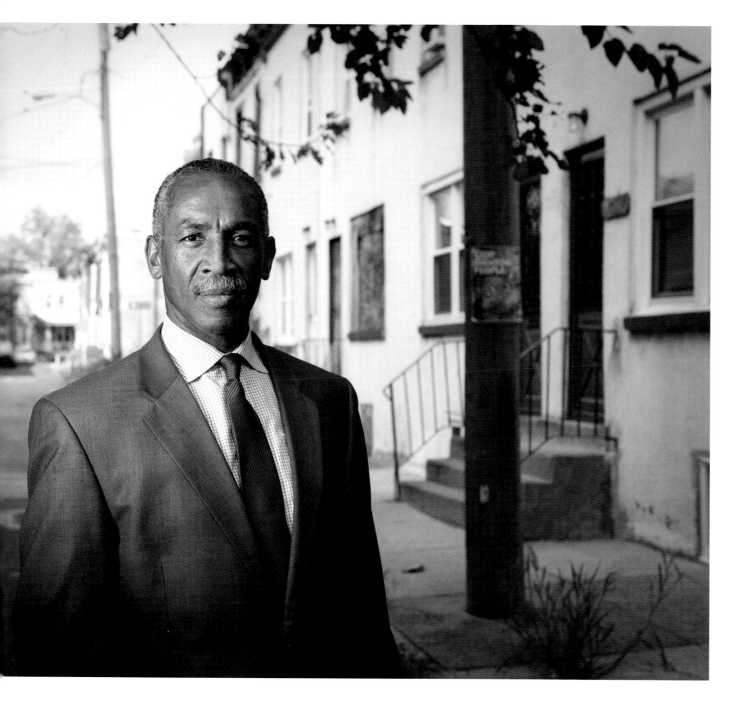

*"I wanted them
to know
that although
I was in prison,
I was a
good person."*

"If I give you a gift, you are probably going to think you have to give me a gift back or you're going to go through this calculation in your head about why it's not necessary. I think the reason we exchange Christmas gifts and the reason we may want revenge comes from the same place."

Howard Zehr has been called the grandfather of the restorative justice movement: the notion that justice can be about repair, responsibility and healing rather than just punishment.

A retired professor from Eastern Mennonite University, Howard is an accomplished photographer and an author who has published several books, including *Doing Life,* a series of portraits and interviews with people who are serving life sentences in prison. In the 1990s, Howard interviewed Tyrone Werts for *Doing Life.* Werts also was interviewed for *A Peace of My Mind.* His interview can be found on page 28.

As a photographer, Howard tries to change the language of photography. He says it's very predatory. "You 'shoot' pictures, you 'take' pictures, and so forth. I've tried to help people think about a different way of conceptualizing photography. If you think about how a photograph happens, you don't take it. The image is reflected back to you and you receive it. It's much more like meditating."

T HE CRIMINAL JUSTICE SYSTEM asks three questions: What rules were broken? Who did it? And what punishment do they deserve? Restorative justice is about asking a different set of questions: Who's been hurt? What are their needs? Whose obligations are they?

We go on to ask: What are the causes of this situation and who has a stake in this? What kind of process do they need to resolve it? The justice system and school disciplinary systems are offender-oriented, and this is much more victim centered.

One of our biggest challenges is for victims and others to understand that we are not asking people to forgive or to reconcile. This is about meeting the needs of those who have been harmed, and about helping those who caused the harm to take responsibility.

If you choose to forgive, that's up to you. If you decide to reconcile on some level, that's up to you.

Statistically, people who choose restorative justice techniques are more likely to achieve some degree of forgiveness or reconciliation, but it's a byproduct.

I think there's a human need for balancing the score. There are negative ways to do that and there are positive ways. The criminal justice system tries to reinforce some important things, but it does so in a really negative way. It says, "You harm us, we're going to harm you." To mitigate that, we have to bring in other values. Inherent in restorative justice is a vision of how we want to live together. I often talk about three core values of restorative justice: respect, responsibility, and relationship.

I'd love to see restorative justice become the norm. I'm not terribly optimistic even though it's expanding at a great rate. There are huge obstacles, not just in our legal training but in our economic system. We have a whole economy based on the prison industry. They are not asking us to be less punitive. In fact, they're out there lobbying for more prison beds to be filled.

I'm a historian by training, and as I've gone back and looked at Western history. We are a punitive culture, and it's constantly refreshed by violent films, by our military activities around the world, and so forth.

What excites me is when people tell me about how they live differently. We did a training for police in another country and the head of the ministry of the police department said, "You know, if we're serious about this, we're going to have to change how we relate to each other here in the department." After one day of training, he said, "My daughter wrecked our car last night, and because I'm in this workshop, I responded much differently than I normally would." That kind of thing is really encouraging.

Restorative justice can be the force behind that kind of change in people's values and behaviors. That's all we're asking for.

PENNSYLVANIA

W.VA. MD.

●
Harrisonburg

VIRGINIA

HOWARD ZEHR
**HARRISONBURG
VIRGINIA**

YANINA CALDERONE
**HARLEM
NEW YORK**

Yanina Calderone was born in Guatemala City.

Raised by her mother and two grandmothers, she moved to New York City at age 14 to live with her father. She cried every day for the first three months, though now she loves living in Harlem.

Yanina was raped at age 15 and became pregnant. She decided to keep her "little froggy," the son that jumped in her stomach. Rather than let a violent act ruin her life, she decided to funnel all of her love toward her child.

When Yanina left an abusive husband, she made ends meet by selling drugs and she got addicted herself. She joined Association Neta, a street gang formed in the Puerto Rican prison system and brought to New York. Today she is involved with a program called AVP—Alternatives to Violence Project. Its mission is "to empower people to lead nonviolent lives through affirmation, respect for all, community building, cooperation, and trust."

I WAS A REBEL. It started when I was 15 years old. My parents got divorced. My families were separated. I got mad at everybody. I wanted to take revenge, including on my parents. Instead of hurting them, I hurt myself. I learned that lesson now. It took me years.

With everything that I was doing, my conscience was telling me, "You're not right," but I wanted to be tough. I did things that I was not proud of.

I wanted to change because of my children. I had an abusive husband for seventeen years. Like other women, I thought that staying was the right thing to do because of the children, but one day I said, "I can make it." That's when I changed my life and started being positive. I said, "I can do it." My kids were growing and I talked to them.

They were like, "OK. Let's leave," and I did it.

I was scared, but I'd been scared before. I'd been scared of dying from a bullet. I'd been scared of getting killed by a drug dealer. I'd been scared of my ex-husband.

I did it, even though I did it the wrong way in the beginning. I started selling drugs. I couldn't get nothing else. That was the easy way to make money. I became an addict also. I was addicted to heroin. Nobody knew. I came to my kids and I told them, "Listen, I need help." That's ten years ago now. My little one was there for me. Every single minute I went through pain, he was there for me. That's why I say, "Never again." Not even a temptation, not even a thought of it because of what I've been through.

A good example of peace in my life? When I let go of all the hurt and painful thoughts that I have in me, and I decided to do something for others instead of me.

There was this lady who was going through domestic violence. I knew it, but I didn't ever say anything until that day I saw her crying. I talked to her. I said, "Are you afraid of him? Don't be. That's how they get you." Not to make her feel like she was doing something wrong, but the other way around. She asked for help. I felt that peace on myself.

I'm like, "I helped somebody. I can do this more often." I have so many experiences in my life: addict, victim of domestic violence: rape victim.

I can talk about it now. For seventeen, eighteen years, I never told nobody that I was raped. I never told no one that I had a son from rape. The one I gave my love to, my oldest son. I dedicated myself to love him. I wasn't going to give up on the little creature.

Forget about the past. We all make mistakes. Who am I to say what you're going through? Who am I to say what you're thinking? I did that before. I tried to hurt myself to hurt others. It didn't work. I don't regret what I have done in life because it allows me to help others. If I can stop you, I stop you. Just let go. The past is the past. Live in the future.

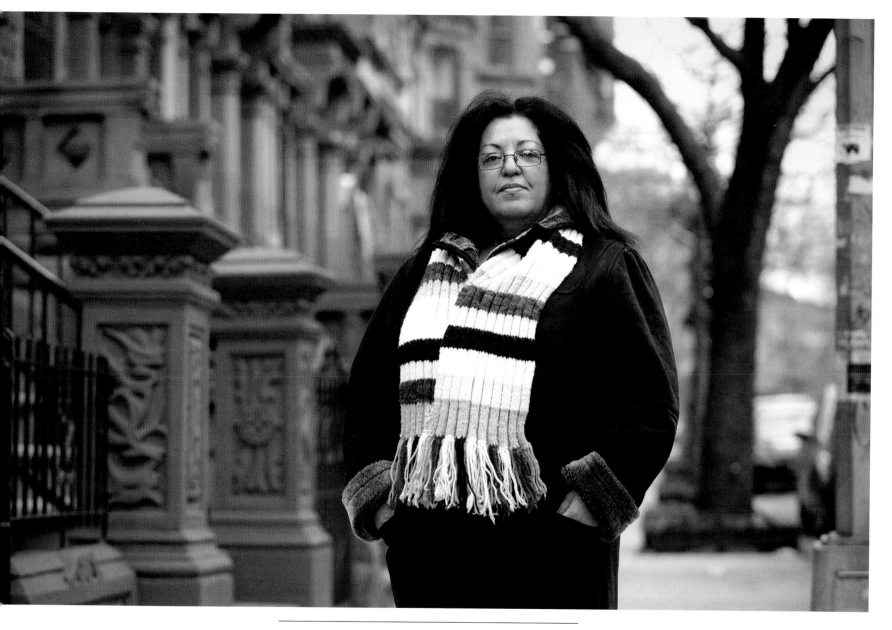

"I let go all of the hurt that I have in me,
all of the painful thoughts that I have, and I decided
to do something for others instead of me."

DONNIE PHILLIPS
**BOSTON
MASSACHUSETTS**

*"Love your fellow
man because
just like violence
begets violence,
I think that
love begets love."*

Donnie Phillips lost his sight at age 21. He is a disability awareness trainer in Boston, Massachusetts, and a spoken word artist who goes by the stage name Uncle Third Eye.

I HAVE GOOD DAYS AND BAD DAYS. Naturally, since I remember seeing at one point in my life, I miss it. But for the most part, I've learned to adapt—the way I think humans can adapt to almost any situation.

Obviously, my biggest disadvantage is that I can no longer see the faces of my family and friends. But God has blessed me with a good memory, so I remember what people look like. I remember their smiles and the colors of the rainbow.

I love people from all walks of life, in all colors, shapes, and sizes. Everybody has something to add to the world and I try to pick up on that. I try to learn from the brother or sister who thinks differently from myself. The brother or sister who speaks a language different than my own.

I pride myself on being Uncle Third Eye, the people's poet. My ultimate goal is to provoke the listener or the reader to bring about peace or move in a positive direction. I talk to everyone without reservation, discrimination, or judgment. I'm trying to reach a younger audience through my poetry. I do this one called "Blind," because there's blind and then there's being blind.

Blind

Shh, shh . . .
don't look now but you know there are none so blind as those who will not see
of ignorance they're guilty and so they will not be free from rumors, lies, or misconceptions, and why?
well because instead of the truth, they rely on misinformation
outright deception, but guess what?
outside the house of truth we all need protection
and indeed knowledge is a blessing
but—and take this as a lesson—
one needs to ask intelligent questions and refrain from guessing
and of course it's up to you,
you're going to do you, so go ahead and do what you do
but whatever you do, keep in mind
eight out of nine times, bigotry and/or a closed mind
serve only to shut down the lines of communication
leaving you and yours in a funky and uncomfortable situation
so I say stifle not that which can be vital information
but rather like the strings of the united nations
just let the conversation flow
for by doing so we may all grow
and you're not blind yo, so even if you don't say so
I know you feel the same way bro
right? right?
what?

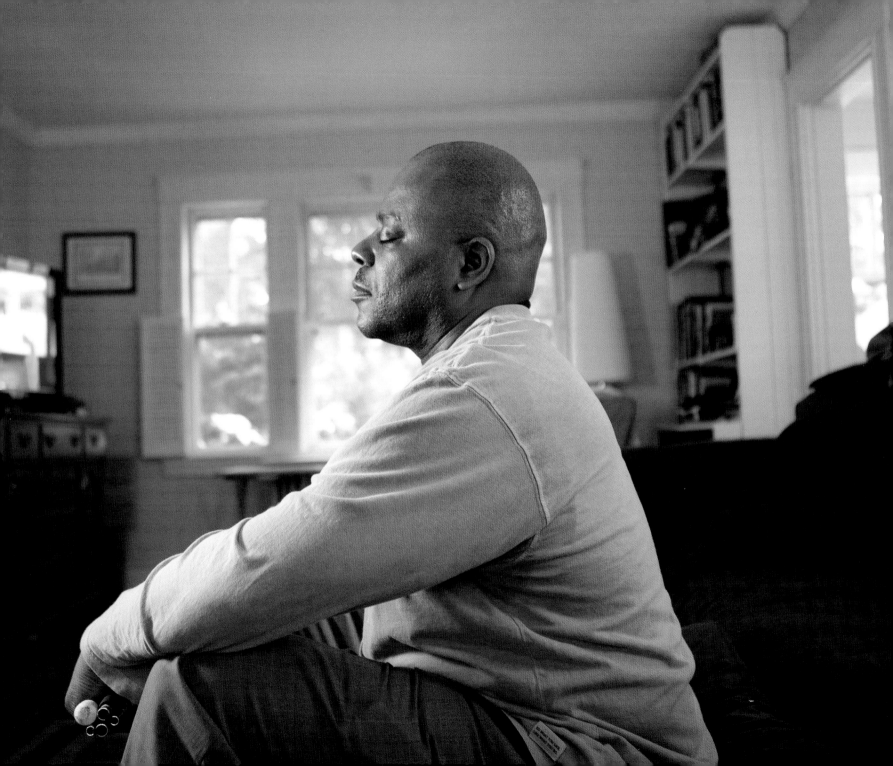

the central states

NEBRASKA

Lucas ●

KANSAS

TEXAS OKLAHOMA

ERIKA NELSON
**LUCAS
KANSAS**

"A lot of times it's much more important to listen instead of being the one telling the story."

Erika Nelson lives in Lucas, Kansas, a rural plains community that is a hotbed for grassroots arts. After selling all of her possessions, Erika traveled across the country, living in her vehicle and visiting small arts communities. Her search for a place to settle ended when she saw a house in Lucas sell at auction for $1,000.

Erika talks of the understanding that has developed in Lucas among some of the traditional farmers and the unconventional artists who live and work beside them.

As the creator and curator of the World's Largest Collection of the World's Smallest Versions of the World's Largest Things—a traveling collection that celebrates our country and shares its stories—Erika encourages people to reignite their sense of wonder about the world.

L IFE IN A SMALL TOWN can be challenging in that you don't get to pick and choose who you associate with. You still have to get together as a community to produce something or to get something done, and that's one of the great things about Lucas. It has a population of 400 people, so it's really important that you do things even if you don't always get along with everyone involved. You may have to say up front, "I can't work with that person right now. Maybe on the next project we'll be at a different place."

One of the advantages of being an outsider coming in, is that you can be a little bit of Switzerland because you don't have that blood relation to anybody in the community. There are no schoolmates, I don't know the rivalries. You can use that non-blood card to say, "I don't know what your rivalry is so why don't we just do this anyway?"

Lucas has embraced some really off beat, odd, quirky use of material things. If you have a work ethic, it doesn't matter whether or not they understand what you're doing, they understand that you care about doing it and they'll support you.

I equate my set of jobs in the art world to farming: you make hay while the sun shines. It's project based. Some people in Lucas didn't think about arts as an industry the same way they thought about their own jobs. But we were open to people asking us questions and vice versa. Asking them how the combine works is kind of like asking me about the kiln I just bought. It's an important part of how I do my job. They equate art with work here and, in a rural community, that matters a lot.

Peace starts from within. You have to be at peace with yourself or, at least, you have to recognize what those obstacles are for you to obtain any sort of peace. One of my obstacles is a normal thing for artists: I often feel misunderstood. People don't know what my motivations are, even though I think they're really clear.

Sometimes during the creative process, you want to play without any rules or restrictions or without even thinking about why you're exploring something the way that you are. It could be easy for somebody who doesn't understand the creative process to say, "Well, that's stupid. What are you doing that for?" When you're in the middle of it, you don't know why, but you know that for some reason this is really important for you. You just want to do it and see what turns out.

Even getting a critique in the middle of a process from fellow creative types sometimes ends up being a stopping point. You start thinking too much about how is this going to be received as opposed to just following through with a process that you know is important to you. Misunderstanding somebody else's creative process can be a stopper.

As human beings, we search for the answer to why we're here and how we can get along better with people and have a positive influence. I was brought up in a community, but I spend a lot of time alone on the road. Those alone points are connected by meeting a bunch of people on the way. Big groups. Lots of alone time. Big groups. Lots of alone time. So I get this overstimulation and then lots of solitude to piece all this stuff together. I find myself thinking about things an awful lot on the road. There's a continual quest to figure out why we do what we do and I don't expect there ever to be an answer, just as I don't know if there's an answer to 'how would you achieve peace in your life?" I think it's part of the journey and the process.

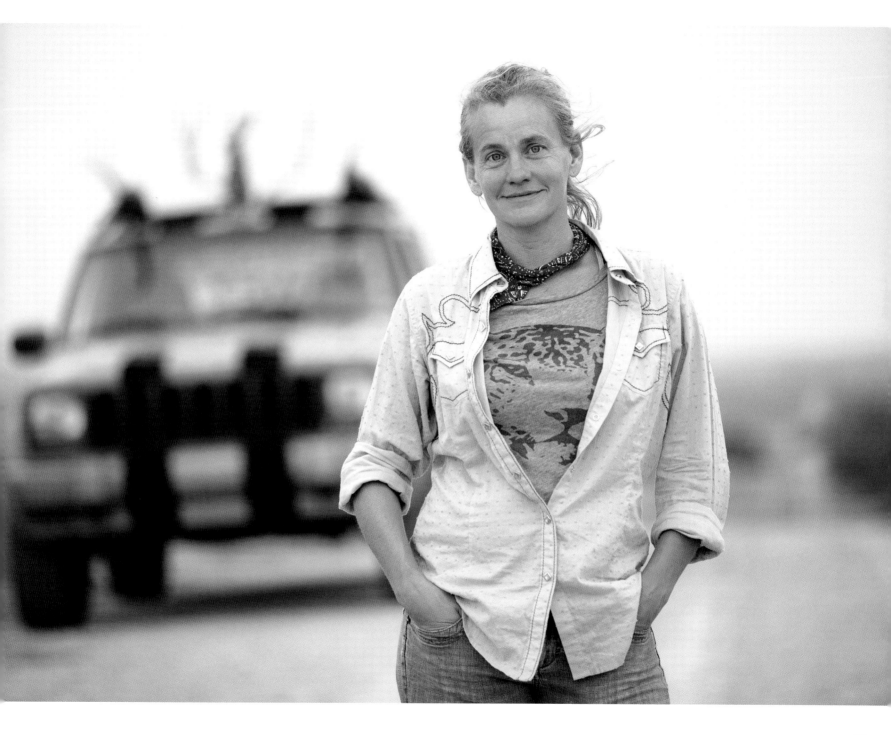

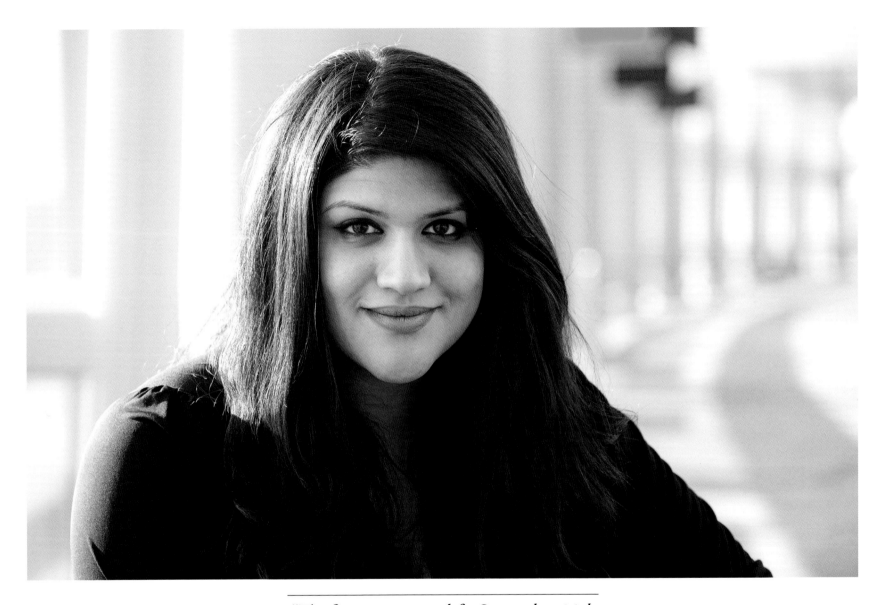

"The first time in my life, September 11th,
I realized that when we try to define people
in large units, define a concept by labeling
an entire group of people, it's really problematic."

Maham Khan was a freshman at Harper College in Palatine, Illinois, in 2001. At the time, her Muslim faith was very private to her and she didn't speak about it publicly. As a new student, she recognized the need to gain leadership experience and decided to join the Muslim Student Association, which had been somewhat dormant for years. At the first meeting, she was elected president. That fall, following the September 11 terrorist attacks, she found herself leading "one of the most important organizations on campus." Also that year, she began organizing interfaith dialog sessions to help people build understanding through meaningful conversations. It is an effort she continues today.

THE IDEA WAS to get people comfortable with interfaith dialog and interfaith cooperation. They wanted to understand, so they said, "We'd like a Muslim to come in and speak." That comes with great pressure because then you're the one person speaking for a multimillion-member faith-based group.

We had a beautiful talk. At the end there was a Q&A. A gentleman gets up and says, "You're very charming. You're very charismatic. You're a lovely young lady, but what about all these Muslims in the Middle East? Can you deny that that's the true face of Islam?" I said, "Why can't this charming, beautiful face be the true face of Islam?"

Why must we say it's one or the other? The reality of faith and of existence in general is that it is undefinable.

I meet people who may have never talked to Muslims before, or people who had never had an honest conversation about what makes them comfortable or uncomfortable about different religions. I try to make myself available as a source of information, or at least as a first point of contact.

It's hard to believe that there are people who are that sheltered, who have never sat down and had a conversation with a Muslim about what we believe. In part, that's a problem of our institutions because we are taught that you don't talk about religion in the workplace. You don't ask someone about their culture or identity or where they come from. In turn, that limits our ability to have honest conversations with people, or to become aware of another's style or ritual.

We fear that which we do not know. The only way to understand is to expose, but we aren't allowed to because of political correctness. We have this institutional problem, and I try to break that barrier. I say, "To hell with political correctness." If you're uncomfortable being on an airplane with me, let's talk about why. I bet we have a lot more in common than you think. People are terrified of having honest raw conversations about race and religion and gender issues because honesty reveals unpleasant things about ourselves. We may not want to confront what we discover.

It's idealistic to believe that there will be a peace that takes over the world. Conflict is inevitable. It's not so much about attaining peace as it is the attempt to attain peace. I don't think we can attain world peace, but one person, focusing on relationships, can create peace between two people, which is contagious. It's like an epidemic. Peace between two people is surely something that can spread.

There's an image that describes heaven and hell. In the image of hell, there's a big pot of stew and really large spoons. There's people around the stew, and they want to eat. They're trying to feed themselves, but the spoons are too big and they can't maneuver the spoons to get the food to their mouth. It's logistically impossible. In hell, they keep trying to feed themselves again and again, and they are unsuccessful.

You go into heaven, and it's the exact same scenario. There's the stew and the really large spoons. Except in heaven, the people figure out that they can feed the person across from them because the spoons work really well that way. They feed one another. I don't remember much from high school, but that's the one thing that sticks out in my mind, that image of heaven and hell.

There can be all these resources, but if we don't cooperate, if we don't submit to the fact that the person across from you might be hungry, too, and that you must serve one another, everyone will be left hungry. We can find peace together, or we can be left desiring.

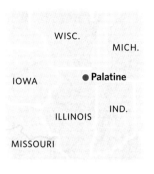

WISC.

MICH.

IOWA ● Palatine

ILLINOIS IND.

MISSOURI

MAHAM KHAN
PALATINE
ILLINOIS

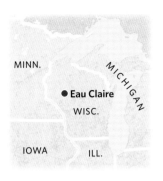

MINN.

MICHIGAN

● Eau Claire

WISC.

IOWA ILL.

PHILLIP SCHLADWEILER
**EAU CLAIRE
WISCONSIN**

Phillip Schladweiler is an Army veteran who
served two tours in Iraq. On February 22, 2006, six years to the day of his enlistment, he was wounded in an IED attack and lost the vision in his right eye. Now an art student, Phillip has photographed the shrapnel that was removed from his body as part of his journey to heal himself and others.

PEACE TO ME MEANS SAFETY and sacrifice. Even though I was in combat, I felt safe. I felt at peace because I knew other people were sacrificing with me. That was important. These people would give their lives for me and I would do the same for them. Having that brotherhood, even in a chaotic situation where you're getting shot at every day, I felt peace.

I view my time in conflict differently than a lot of people with PTSD. They take it personally. Like the insurgent was shooting at you and not just at the flag on your shirt. I look at it the other way. They have no idea who I am. I would much rather have a beer with them than shoot at them, but the circumstances being what they are, you have to accept that they're going to shoot at you.

I didn't take it personally because I looked at it like a job. My job over there was thirteen fox forward observer, to protect the people around me and make sure my brothers in arms were safe. If we were attacked, I would respond appropriately and accordingly.

I don't have a lot of turmoil over it. I have my moments. I have issues with dreams and stuff, but overall, I don't take it personally that they shot at me.

My art project is titled *Shrapnel*. Three of the pieces of shrapnel I've photographed were removed from my body. I get in real close with a macro lens to these tiny pieces of shrapnel and take intricate and detailed shots of them. The middle piece is blank to represent posttraumatic stress and I call that one *Wounds Unseen*. It's dedicated to the soldiers who come back, who are wounded or who commit suicide because of PTSD. We don't have a cure to combat what we've seen. I think these pieces of shrapnel speak to a lot of veterans and wounded soldiers. I'm looking for other veterans to participate in this project. I hope to give a voice to veterans and say, "Hey, it's OK to talk about this stuff, even if it is to civilians."

I did a job like I was supposed to do. In the military, you had one goal and it was to stay alive and keep moving forward. I try to keep that going. I try to keep focused and moving forward as much as possible, and I know I have other people's backs, regardless of whether they have mine.

I am close to my family and friends, but I still feel this solitude. About the only time I don't feel it is, sadly, when I go to a funeral of one of my battle buddies. We pick up like we've never left and I feel that safety again. If you've been to combat with someone, there's a bond that you can't break. You've experienced something that a lot of people haven't.

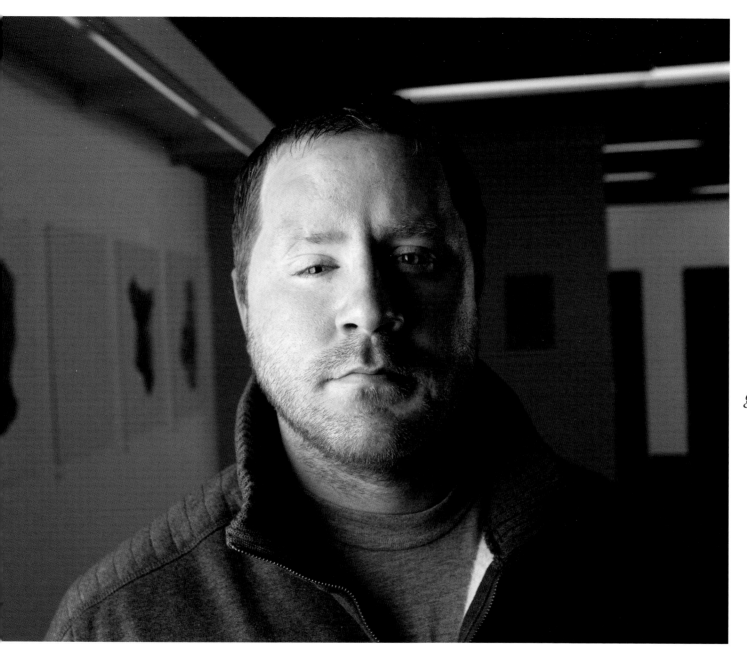

"Be brave enough to sacrifice a little bit of who you are, to be civil, and give people hope that things will change eventually."

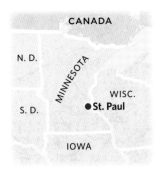

DEANNA THOMPSON
ST. PAUL
MINNESOTA

Deanna Thompson was diagnosed with stage 4 breast cancer at age 42 that had metastasized to her bones. The doctors told her she had fewer than five years, but when I interviewed her, it was more than six years after her diagnosis. She lives in St. Paul with her husband and two daughters. She teaches religion at Hamline University, and she talks about living when you know that you're dying. Deanna's understanding of peace has shifted from an international focus to a local and more personal focus over the past few years.

THERE'S A HUNGER for people to have real and deep conversations about cancer, but also about the suffering that we go through in life. I don't feel like we have enough spaces in our culture to dig deeply into those experiences. We don't know what to do when we ask somebody how they're doing, and they don't say, "Fine, thanks. How are you?"

We shy away from those conversations because we don't know what to say. We're afraid we're going to say the wrong thing and sometimes we're really hard on each other for not getting it right. It's not that people don't say stupid things. They do. But I'm hoping we can have a little bit more grace in dealing with each other.

I'm an educator, so on good days, I'll try to teach a little bit, "Here is why I don't think God gave me cancer. Here is why I don't share that particular perspective."

But you don't always have the energy or time to reeducate, so, sometimes, I just think that the person had good intentions, and let it go. It's also important to say that those of us who live with cancer or who are dealing with other awful things have many days that aren't good days. When somebody says something hurtful on a bad day, I can come back with a retort that is also offensive. So I try to ask for forgiveness where possible, learn from those mistakes, and hope that even on bad days, the response might be more measured.

How do you live while you're dying? It's what all of us are doing, but those of us with stage 4 cancer are doing it in a different way, and understand we're dying more acutely than people who aren't sick.

Understanding peace while living with stage 4 cancer is trying to practice radical acceptance of what is, without giving up. I don't think it means to admit that my life is almost over and not make plans for the future, but to realize that I'm not in control and to come to terms with that. At the same time, peace for me is a very corporate communal concept.

Over the past five years, I've become incredibly grateful and humbled by the way we are interdependent. In our society, we stress independence so much. For me, as a theologian, as a Christian, as somebody who's held up by lots and lots of people, peace is also a communal thing. And the relationships that I have with other people are integral to any experiences of peace that I may have.

Peace is not just the absence of conflict. Getting to a place of peace or being in a peaceful relationship means you have to go really deep. We are unsure of how to do that, because it's complicated and because we all have insecurities.

We feel like we don't ever have enough time. To deal with the heart of the matter takes time. To sit with people who are grieving takes time, and our current pace discourages us. We like to wear how busy we are as a badge of honor. When you get very sick and are confined to a small space for a long period of time, all that busyness looks superficial.

People aren't comfortable being vulnerable. When I got sick, it became clear that I couldn't do any of this, and I realized that saying yes to other people who want to care for us was an incredible experience of grace. It was an overwhelming experience. Opening yourself up to being cared for and ministered to and prayed for has opened up for me an understanding of gratitude and a sense that all will be well even if my time here isn't too much longer.

Cancer is definitely not a gift, but in the worst of times, I've experienced the most beauty and the most peace and the most grace. I have to hold those two things together and not deny either one.

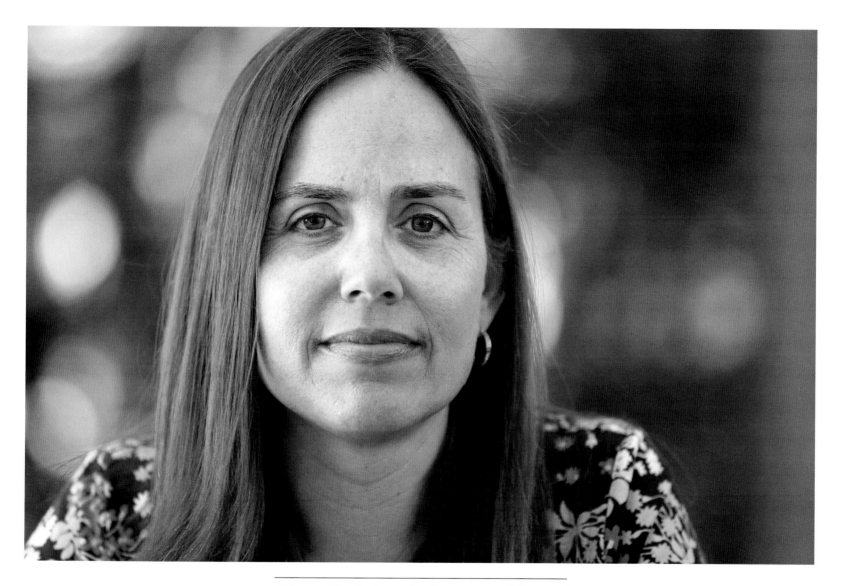

"Initially, I thought I was on sabbatical to get ready to die. Then it became clear that I wasn't dying right away."

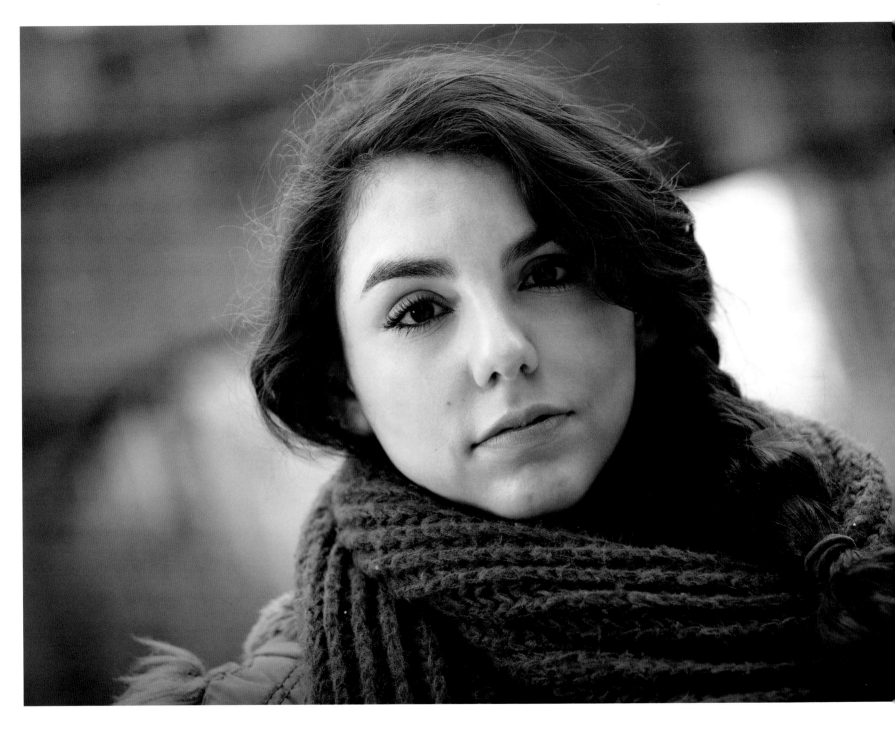

Gina Laff was born in Paraguay and adopted at age one by a couple living on the north side of Chicago. Her father holds Gina to a high standard and she describes him as a "stubborn old man." At first, out of frustration over their difficult relationship, Gina pulled away from her father, but eventually, she decided to embrace him without judgment. She keeps a journal of their frequent conversations and his advice. Gina believes their exchanges have made her stronger and her acceptance of him brings her peace.

M Y PARENTS ARE POLISH AND JEWISH. I always knew that I was different from my family and they always made it clear I was adopted. It was just a random moment that allowed me to come here. The adoption lady said to my mom, "OK, which daughter would you like to adopt?" She held up two pictures and I was the one who got picked.

My father is almost 70 and he has dementia and cancer. He has been sick throughout my life. I remember him telling me when I was six years old that he might not make it to my graduation. I've always had to deal with his health issues and accept that my father might not be there at the end of the day. People might look at it as a horrible experience, but I look at how strong I've become because of that.

My father told me he was a loser in high school and only focused on his grades. He had no friends. He graduated college and dental school when he was 20, which I'm proud of. He's a tough guy. He's been a tough dad. He criticizes me about everything because he knows I have the potential to do more or to be better.

I felt like he was looking down on me and so I pushed him away. Then I realized that he might not be here tomorrow. Why would I worry about what he said to me when I could talk to him about how I can improve my life or improve a certain situation.

Sometimes I still push him away. It's a security blanket to make sure that he can't say something that will hurt me. My fear is that he'll say something that's not nice and that will be the last thing he says to me. But I've decided I can't be mad and hold grudges against him. I take his comments to heart and listen to what he says and I make sure to talk to him every chance I get.

Every day I ask my dad a question: "What's your favorite movie?" or "What were you doing when you were 22 years old?" or "What was your favorite college experience?" And I write down his answers in my journal so I'll be able to look back one day and remember that conversation.

WISC.
MICH.
IOWA • Chicago
ILLINOIS IND.
MISSOURI

GINA LAFF
CHICAGO
ILLINOIS

"I find peace the most when I'm listening to people talk about their problems or the issues going on in their life. I feel like it's a way for me to help someone else."

CANADA

NORTH DAKOTA

MT. MN.

SOUTH DAKOTA

WY. ● Porcupine

NEBRASKA

MYRON POURIER
PORCUPINE
SOUTH DAKOTA

"Let's mend our sacred hoop as a people, not just as Lakota but as a world, of all walks of life."

Myron Pourier

Myron Pourier is the great great grandson of Black Elk. He lives on the Pine Ridge Reservation in South Dakota and has proudly served in the U.S. Military, as well as on the Tribal Council of the Oglala Sioux.

Myron is working to change the name of Harney Peak in the Black Hills to Black Elk Peak. The mountain, sacred to many Native Americans, was named after General William S. Harney, who led an 1855 punitive battle that resulted in the massacre of nearly 100 native men, women, and children.

When Black Elk was 9 years old, he had a vision that he related later in life: "I saw that the sacred hoop of my people was one of many hoops that made one circle, wide as daylight and as starlight, and in the center grew one mighty flowering tree to shelter all the children of one mother and one father. And I saw that it was holy."

MY JOB AS A DESCENDANT of Black Elk is to maintain a peaceful campaign for our cultural diversity, to unify people of all walks of life through a mutual understanding of who we are, and to respect one another through compassion, humility, and love.

We use a very powerful word when we finish praying: *Mitakuye Oyasin*. Many people say it's like the word amen, but it's not. Its English translation is "we are all related." Through prayer, we're all related. Through all walks of life, we are related as one in unity.

Right now I don't think there's a group of Native Americans in the United States that trusts the U.S. government or the Europeans.

This is based on historical trauma, and our treaties being broken continuously.

We had trillions of dollars in gold taken out of our Black Hills, stolen from us. We're the poorest county in the United States. Because we did not have the power and authority, they overwhelmed us and put us on these reservations, and broke the treaties.

How do we bridge that gap? We need to take our message to the federal government through peaceful prayer and through movements that bring us together in an honorable way.

It would be a big step for the government to rename this mountain Black Elk Peak. It will bring spiritual healing, not only for our people, but for all walks of life. It's going to unite many people. It may even be a starting point for a whole new peaceful movement. I know I'm going to continue moving forward through cultural diversity. I welcome those that want to join me on this journey and spread the word to all walks of life. We don't know when we're going to leave this world. Nobody knows but the creator. My thing is to move fast and move quick and spread the word in a peaceful way.

The Sioux don't have a word for goodbye. We say *toksha ake*—until we meet again. I believe that if I don't see you again in this life, I'm going to see you in the next life. Toksha ake. Until we meet again.

As this book went to press, on August 11, 2016, the Federal Board of Geographic Names voted 12-0 to officially change the name of Harney Peak to Black Elk Peak.

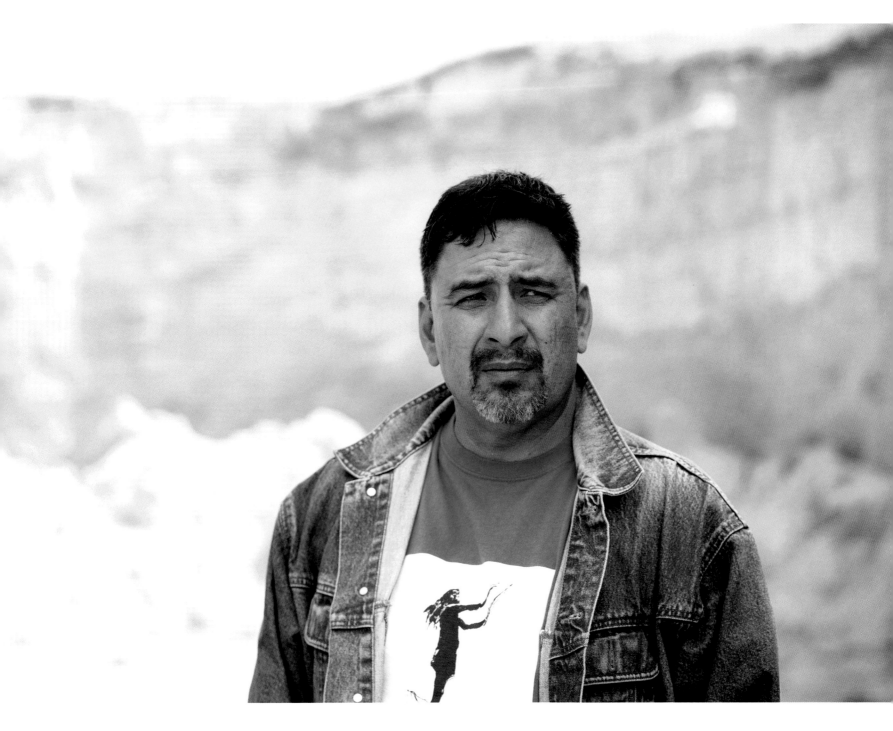

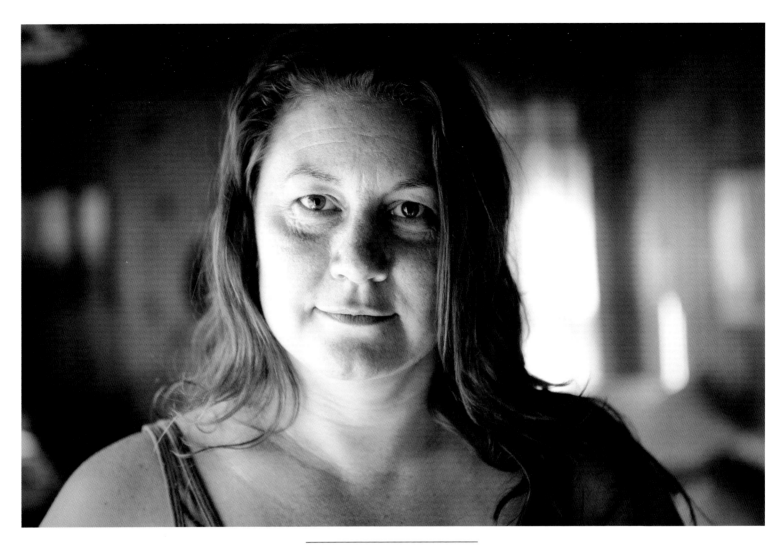

"When I'm not healthy,
when I'm not doing well here,
how can I be of help and be peaceful with you
if I've got turmoil going on here?"

Leah Prussia

grew up in a primarily German-Norwegian family, but as an adult, she embraced her Anishinaabe heritage, as well.

Leah holds a master's degree in social work and works as a college instructor and clinical social worker. She has struggled with depression for much of her life. When she finally found the right combination of therapy, medication, and spiritual practice, she says it was like seeing color for the first time. She came alive.

Leah believes that many people struggle with balance in the mental, emotional, and spiritual realms. She works with her clients to discover an inner peace that she hopes will influence a greater peace beyond.

I'VE STRUGGLED with mental illness since I was in fourth grade. I remember feeling different from other children. I intuitively felt something wasn't quite right. I excelled in everything in school and graduated salutatorian, but I've always felt this deep sadness. My mom and dad always asked, "Why aren't you happy? You've got a really good life." They didn't understand depression.

I got my bachelor's degree in psychology. I didn't know how to help people when I wasn't doing well myself. I knew I needed to address my own stuff before I could be effective with anybody else. Eventually I saw a psychiatrist who tried a number of different antidepressants. Finally, one hit and it was like I saw color for the first time. It was amazing. I felt alive. After finding that right medication, along with therapy and getting grounded on a good spiritual path, I'm in recovery. I'm doing well. I'm staying out of the hospital, enjoying life, and feeling alive.

What does peace mean to me? Personally, I think we've got to start from within. We've got to take a look at our own houses, our own spiritual vessels, and be able to accept who we are, rejoice in who we are, and walk gently and genuinely. Part of my work is to help people come to that conclusion through therapy.

When I think about peace, I think about balance and acceptance. Not being envious of or wanting what someone else has, but genuinely being content in where we are physically, mentally, emotionally, and spiritually. That's hard to do in the United States. The values of our country are so different from Anishinaabe values, which are communal. You do what's best for the community. In this country, we step on each other's backs to get the best job, drive the nicest vehicle, live in the largest house.

I don't pray for wealth. I don't pray for a nicer house or a bigger car. I seek inner peace. That's always been the struggle. I start at the micro level, with the individual or with myself. My hope is that, as people start to love themselves, they'll be able to love and respect each other and, eventually, this micro love will move to the mezzo and the macro levels and we'll have ultimate world peace.

We're all hurting souls. With mental illness, it's often a very intimate, self-consuming, internal process. When people start to feel better, they start to come outside of themselves and look around. For me, a sign of seeing someone getting well is when they're not consumed with their symptoms, but start to help or notice others: "Hey you look really nice today. Hey, I really appreciated when you came over to visit me when I wasn't feeling well." And they start to engage with the world around them.

Mental illness is a lonely place. So when I work with people, Ihelp them peek around, to kind of come out—like the turtle. Is it safe? Maybe it isn't so bad, so I'll stick my head out a little bit further. It starts here. It starts with each one of us.

CANADA

N. D. MINNESOTA

● New York Mills

S. D. WISC.

IOWA

LEAH PRUSSIA
**NEW YORK MILLS
MINNESOTA**

NEBRASKA

● Nicodemus

KANSAS

TEXAS OKLAHOMA

ANGELA BATES
**NICODEMUS
KANSAS**

Angela Bates is director of the historical society in Nicodemus, Kansas, a town that was settled after the Civil War by emancipated slaves who sought freedom. All current 16 residents, including Angela, are direct descendants of those original settlers. It is the only remaining all-black town west of the Mississippi River. Angela sees herself as a descendant of people who had vision, determination, and great faith in God. She honors their memory by preserving their heritage and by working for positive change in the world.

Angela says that when we first meet someone, we may base our initial perceptions on physical traits, because we have little else to go on. But as we get to know each another, we are able to see the human spirit, which has nothing to do with color.

THIS TOWN IS SMALL in terms of population, but it's huge in history. It represents an entire chapter in American history where African Americans were moving west after the Civil War. The opportunity existed in the west to own land and to govern themselves in an all-black town. I'm a descendant of people who had a vision, determination, and faith in God, and they made their dream a reality. I carry with me the gene of determination, the gene of faith, and a desire to make a difference. I take the stewardship of Nicodemus very seriously.

I start off each day—before I even get out of bed—by tuning myself up. I pray and I align my will with God's. I say, "Not my will but yours. I've got my own agenda for the day, but let me be flexible enough that I can read the signs and go where I need to go and do what I need to do."

I wake up in the morning and I know I'm African American. We're living in a society that has not processed the effects of slavery. We're all dealing with posttraumatic stress. We think of the wounded warriors who have PTSD, but all Americans have it. We tend to forget that we have been terrorists in our own land against our own people. Being African American in this country has not been the best experience. We have learned how to be tolerant and adjust to an environment that has been very hostile to us. In many respects, it still is. We cannot escape that. It's present every day.

When I meet people, I want them to know who I am. You may react to me initially as an African American woman, but by the time we finish talking, then you will know me as Angela. You will know my spirit, and it has nothing to do with my color.

Initially, when we encounter someone, we may see nothing but the physical, but as we embark upon understanding each other, those physical differences fall aside and what's left is just the human experience. You're married and you have a wife, and maybe you have some children. Oh, we've got that in common. You like Chinese food? So do I. You start to see that all human beings have likes and dislikes and the same desires and the same basic needs. We all want to be accepted and loved and appreciated. And that has nothing to do with color. It has nothing to do with culture. It has nothing to do with race. It has to do with being a human.

The other stuff is all foolishness. "I don't like you because you're not living on the right side of the tracks." "You're not driving the right car." "I don't like the way that you're dressed." "I don't like people that wear cowboy boots and cowboy hats. They're a bunch of hicks."

We start imposing these biases on one another and what value does it have? What's important is the encounter that we have with one another, the little bit of energy that we exchange with one another.

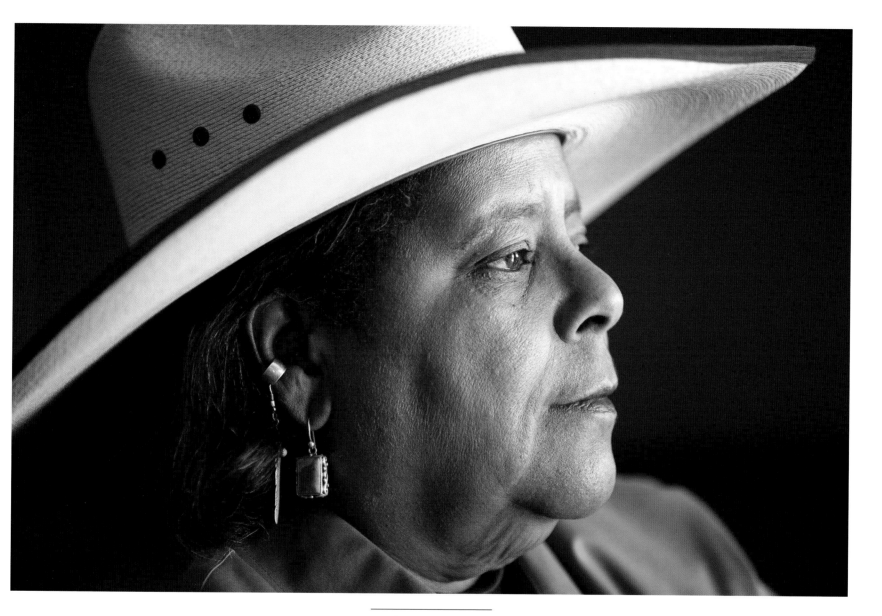

"I have a choice.
How am I going to react
to the world around me?"

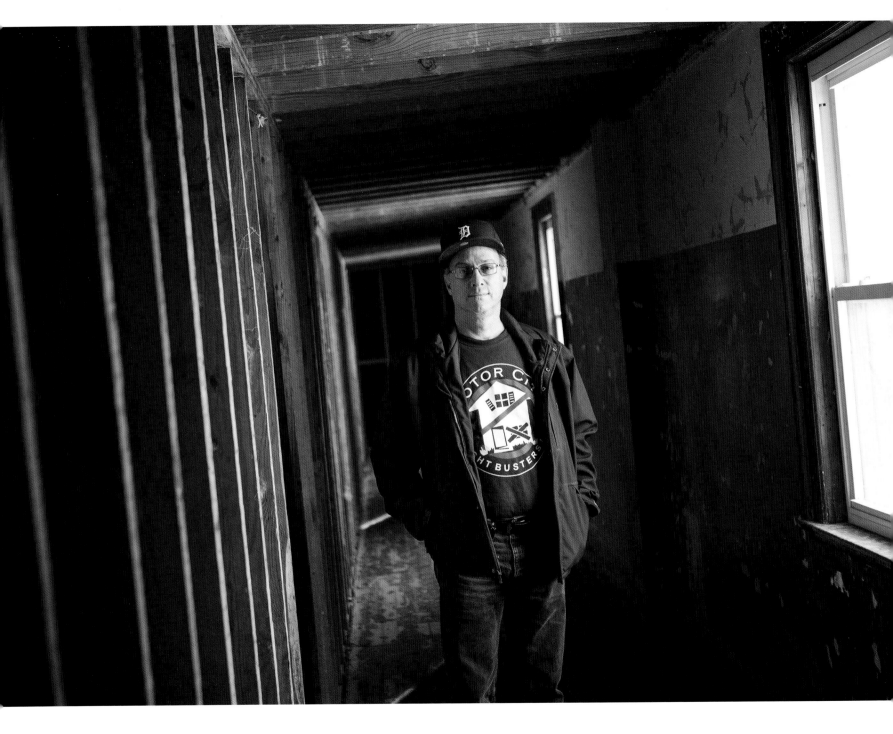

John George

decided to do something about the crack house next to his home in Detroit. He bought plywood, paint, and nails and boarded up that house. Today, more than 25 years later, the organization he started, Motor City Blight Busters, has replaced more than 1,500 derelict houses with gardens and other community assets. Asked why he didn't just move away, John says, "We are out to change the world—and we're starting in Detroit."

THE CRACK EPIDEMIC hit this neighborhood pretty hard. I had a two-year-old son and a daughter on the way when an abandoned house behind mine turned into a crack house.

I called the police. I called the mayor. I called the city. No one would do anything. One Friday night, things got out of hand and my first thought was to pack up and move. But then I thought: I cut my grass. I take out my trash. I pay my taxes. I'm not going anywhere. So I went to the hardware store and bought plywood, nails, and paint. I boarded up the house and cut the grass.

A couple neighbors jumped out of their car after I was halfway through this project and they said, "What are you doing?" I said, "Well, I don't know about you but I'm not going to live next to this. I don't want my children growing up in it. This is negative energy. This is child abuse. I'm not leaving, but I'm not gonna let this fester." I said, "You can either help me or get the hell out of my way." They said, "Well, we want to help." So we worked another four hours and, at the end of the day, the home was boarded, secure, and stable.

When the drug dealers came back, they couldn't get in, and they got in their Jeep and left. I wanted to return a little peace and quiet to our community because the crack house had become a place of negative energy. Criminals are like cockroaches. You turn on the lights and they scatter. So that was our first attempt to stabilize our area. I still live in that same house.

Where the crack house used to be is now a field with bushes and trees. Another abandoned house that we took down is a community garden. Just last year, we planted about 30 cherry, plum, and apple trees, so it's actually an orchard now. That neighborhood liability is now a community asset.

We not only stabilize, revitalize, and beautify the city, but we create ownership. We build a network of people and projects and programs. You're repairing the fabric of the community when you invite everyone to participate. You are creating a peace zone, because now everyone has a vested interest and something to lose, be it a business or a home.

There's real value in cooperation. There's real value when you concern yourself with the plight of others. Don't be shy about helping, loving, and supporting others. It's not what you have, it's what you give. There is great and deep satisfaction when you can help others. There's strength and power in that.

JOHN GEORGE
**DETROIT
MICHIGAN**

"We all know what the problems are, and there are many. But to continue to focus on the problem and not create a solution is a mistake."

AMY ROBINSON
**WATFORD CITY
NORTH DAKOTA**

Amy Robinson is a reporter for a weekly newspaper in Watford City, North Dakota—the epicenter for the oil boom in the Baaken Oil Fields, which took off just as the rest of the nation was in recession. With economic prosperity came social challenges—alcohol and drug abuse, human trafficking, domestic violence—as people flocked to the region for jobs.

Like many other residents, Amy moved to Watford City for a fresh start.

MOVING HERE has allowed me to grow as an individual. I've learned how to depend on myself and work hard. I realize that being alone is OK. Moving to North Dakota has made me stronger in ways I hadn't expected.

When people think of peace, they have a societal view of world peace: Everybody is going to get along. No more war. No more fighting. Honestly, I don't see that ever happening. I think there will always be war and conflict in this world. Ultimately, what's more important is inner peace.

For me, that means knowing who I am, knowing the mother I am, and being confident in my morals, beliefs, and ethics. When you're not fighting inner demons and you're not analyzing and questioning everything, there's an inner peace that's so important. I learned that just in the past year, which is crazy.

There are many facets to fighting inner demons. Women have an insecurity about people accepting them, about their outer appearance, about being judged, and about being successful in a man's world. Any of those things could be an inner demon or an inner struggle. If you can find peace within yourself and be comfortable with the work you're doing, professionally and personally, you've fought those demons and you're at peace with who you are ultimately.

To get past my inner struggles is a day-by-day battle. I'm divorced. I left my ex-husband because he got physical with me in front of our oldest child. Cops were called. He was military. We were living in military housing and he was told to move out for a while. Long story short, two weeks later I had my entire van packed and I was out. I took our clothes, photos, my computer, the kids, and that's about it.

That was a hard time in my life. I was not strong. As a little girl, I always thought, "I'm going to marry one man and we're going to have kids together and we're going to grow old together." That was my dream and I didn't want that dream crushed.

I felt that I needed to stay because I couldn't support myself and my kids alone. I kept making excuses to stay until I finally I figured out that I'm strong enough to do this on my own. I needed to leave, not only for me, but for my kids. I learned that I was stronger than I thought I was, and I'm confident in how I was raised and my morals and belief system. No more bullshit.

I was good at masking my life. I wanted people to think that I was a proud military wife and everything was perfect and we were just fine and happy. He was an embarrassment to me, and it felt like failure. You know what's more important than that? Not crying every day. The person you're with shouldn't make you cry more than they make you smile. If you're crying more than you're smiling, then you shouldn't be in that situation.

Too often, people don't want to get involved. If just one person had stepped forward to say, "Hey, I know something is going on and I'm worried about you. I don't need to know all the details, but I just want you to know that I'm here." That would make all the difference. That's not being nosy. It's not snooping.

People choose not to get involved because they don't want to add drama to their own lives, or they feel that it's not their place to dig into somebody's relationship. You have to look inward and say, "What's the right thing to do?"

If I were to offer advice, I would say believe in yourself. Anybody is capable of anything. If you believe that you're strong enough, everything is possible.

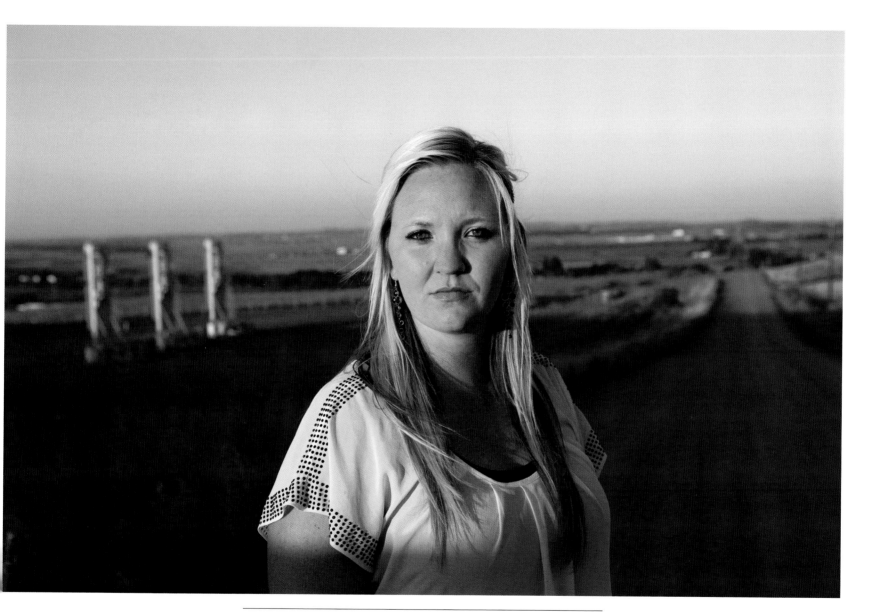

"If somebody would've reached out and just said,
'Hey, I'm here and you can talk to me anytime.
I'll just listen to you,' I think that would've helped me a lot.
I didn't have that."

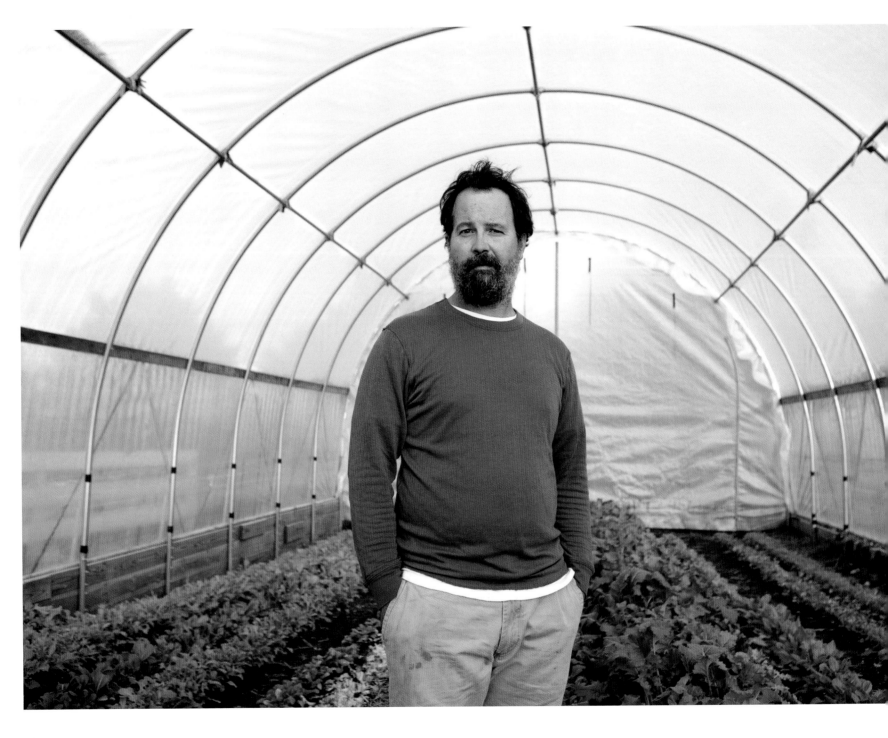

Eric Menzel always had a fascination with food. As he learned more about commercial food production, however, he became increasingly concerned. He saw a system that is geared toward food that is replicable and distributable, but has very little to do with nutrition. In the pursuit of healthier food and healthier living, Eric began farming on a small scale with his wife, Eve, in rural Iowa. Although he recognizes his new career will never make him rich, he has found meaning in his daily routine of hard work and healthy living. He and Eve also discovered they were part of a growing movement that supports building community through small-scale agriculture. Eric finds peace through simple living that reflects his personal values.

THESE ARE MY VALUES: being helpful to other people, having integrity in my thoughts and actions, knowing that I practice what I think and preach, and doing right by my family. This is what brings me closer to peace.

I call what I do food farming. I don't call it organic agriculture because that gets technical. Organic is a federally licensed term that you can't use unless you get certified by a federal agency. The old term for what I do is 'tuck farmer,' which means basically a small-scale producer who grows vegetables and fruit.

Maybe I'm romanticizing it, but the way I conceptualize farming of the past was that people had big families, but they also had neighbors they relied on and shared the struggle with. Today everything is so convenient and leisurely that the struggle is over physically, but there's also no neighborhood. There's the guy with 2,000 acres here, and you've got to travel 10 miles to get to the guy with 4,000 acres over there. Farmers have everything they need, so there's no community in the countryside, or it's really sparse. There used to be interaction between small towns and farmers, because there were all these small businesses related to farming. Most of that has disappeared. So that void is what we are trying to fill with this type of agriculture. People want to get together for a Sunday picnic after a long day of threshing. They want to go pluck a chicken. They want to do things together that make them feel alive.

I feel like food is always in the equation. Everybody has to eat, right? This kind of farming can build community. That's the purpose of it and that's why there's so much fervor about it. It's a powerful thing that people feel close to and want to be a part of.

I have very high standards for food quality. I'm always complaining about the lack of food quality in the world, so I'm not going to go out and just throw some weeds on a plate and expect people to cheer. But I feel like we need to raise our expectations on everything: the way that we act and the way that we behave toward one another. We need to have analytical conversations with one another about important topics. We just can't tweet and text in shorthand. We have to have communication and follow through. I think that's lacking in our society, and I don't think a lot of people want to hear about that. A lot of people would rather just be comfortable and cautious and hang back and I'm not too in to that.

I know that I'm not going to make a lot of money doing this. It's just not possible. A plumber could work for a week and make as much as I do in two months. But I don't want to be a plumber. I want to be happy with myself and I want to make other people happy. Whenever I've been involved in some kind of moneymaking operation, I haven't been happy, so it's just not a choice for me. Some people feel like they have to make a lot of money or they're going to be doomed to poverty. But for me, if I can feed myself and my family, I feel like that's pretty darn good. We're living a healthy lifestyle that doesn't require a lot of money. Actually, the pursuit of money is the opposite of what I'm trying to do.

ERIC MENZEL
SOLON
IOWA

"Peace means that you can look yourself in the mirror and know that you're on the right track. You're not perfect, you're going to stumble and make mistakes but you're working toward creating a better result."

the west

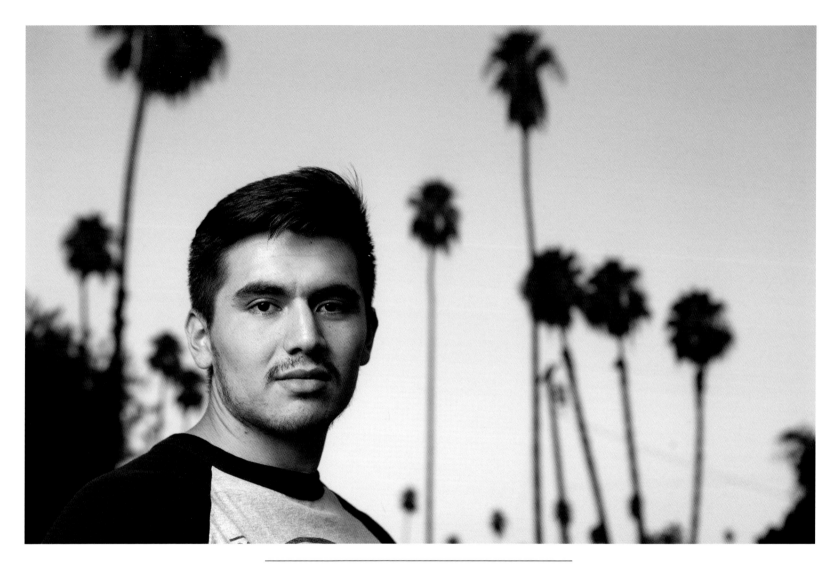

"Everyone struggles. I know that, whether they need to get a job, pay for bills, all that. We do as well. We worry about our family. We worry about our future."

Cesar is an undocumented immigrant who lives in Riverside, California. He was born in Mexico and crossed the border on foot when he was 16 years old. On the journey, he was robbed, nearly died of dehydration, and was almost caught by border patrol agents. Although his mother and sisters are U.S. citizens and his father has residency, Cesar has been unable to change his status. He works odd jobs and hopes to move toward citizenship one day. He shares his story in the hope that it can inspire immigration reform. Although he told me his full name, I have chosen to use only his first.

I F PEOPLE SEE THAT I'M NOT AFRAID, others will be encouraged to get out of the shadows and participate. I am somewhat scared. But it's important people put a face to the issue. We're not just numbers. We're not just 11 million people living here illegally. I'm a student. I'm a son. I'm a brother. I work for my community. People need to see that undocumented immigrants are human beings who are struggling.

We worry about our family and our future. We don't ask for much, just the ability to work and be a productive part of society.

When I think about peace, I think about being able to do what every other person does: go to school, go to work, pay their bills, and have a family. To me, that's peace. I know it's simple, but peace to me would be not having to watch my back or worry that the cops are going to ask about my status. I just

CESAR

RIVERSIDE CALIFORNIA

want to do what everyone else does without thinking that I'm going to get deported or I'm never going to see my family again.

Even though my mother and sisters and most of our family are U.S. citizens, there is no process for me. We've tried to adjust my legal status in the country before, but it's not an easy task.

Mexico is still part of me, but it's nowhere I want to be. Right now, I'm keeping myself busy. I fix cars. I work in construction and cleaning yards. I work in restaurants and places where I'm sure they won't check my status.

I try to live a normal life, even though being deported is a constant fear. Every day when I'm out driving and I see a cop car, it crosses my mind. I try to be a good citizen. I pay my taxes through an ITIN number because I don't have a social. I try to go to school and live a normal American life. Every now and then I hang out with my friends, go out to eat, have a drink, talk to pretty girls—just try to be normal.

I find California very beautiful. Since the moment I got here, it was just amazing. I love the people, even though there are some people that don't like us here. I try not to pay attention to them.

I would like them to understand that we are just like them. We are fighting to feed ourselves and our families. We're fighting for a better future. We're not as bad as people picture us to be. We're passionate about what we do. We have hopes and dreams. We want to do better for ourselves and our families.

I'm not looking for luxury. I just want to live comfortably, have a house, my family, and my car. I think that's realistic. I don't think I'm asking for much, but we have a long way ahead of us.

DAN GALLAGHER
MISSOULA
MONTANA

Dan Gallagher

Dan Gallagher served in the U.S. Army in Vietnam from 1966 to 1967. His job was demolition and mine warfare, and, when he returned home, he was met with protests and derision. At first, he couldn't feel proud of what he had done, or even talk about it, but as time passed, Dan found it useful to discuss his experience. When people thank him for sharing his story, he is only half joking when he replies, "No, thank you, because you gave me a free therapy session."

He says that most veterans don't share their stories because they think people don't want to hear them, or they wouldn't understand.

Dan is involved with the American Legion post and veterans' affairs in Missoula, Montana. For a long time, the peace symbol was a cause of pain and discomfort because it reminded him of the war. Yet, recently, Dan has formed a relationship with members of the peace community in Missoula and discovered that peace activists and veterans are not as different as he imagined.

His journey is told in the 2014 documentary *Beyond the Divide*.

T HE THING THAT COMES HOME with you from war is a sense of service and sacrifice. You saw your friends die. You bring back a sense of camaraderie for your buddies because, literally, you would die for them and they would die for you.

When we came back, we thought, "OK, now we can pick up our life where we left it. Now we get to go to college, have families, and have a house." We'd been told that when you serve your country, there are rewards, and the biggest is that people welcome you back with a level of respect.

The reality, of course, was a shock. I remember a young blonde girl who carried a sign that said, "Baby killer." I remember that girl's face. There was so much anger and hatred in her eyes. I wasn't ready for it.

When something is as unpopular as the Vietnam War, you don't want any reminders of it. Unfortunately, the veterans were the most obvious reminder.

I started doubting myself to the point where I didn't believe I could be successful. Whatever I did [felt like] it really didn't matter. A total loss of future.

Time doesn't heal all things, but it does put distance between them. Little by little, the peace advocates came to understand what veterans had gone through and they started to mellow. Then there was the Iran hostage situation in 1979. The country turned out when the hostages were released in 1981 and there were a lot of editorials talking about another group of hostages: the old Vietnam veterans. That was the turning point.

In the process, people in the peace community and people in the veteran community began to talk. No one who's gone to war wants a war. The peace advocates were genuine. It was a chance, if nothing else, to turn down the heat on the stove.

I was invited to speak at a couple of peace rallies and I did, but my comments focused on veterans. I talked about the fervor, emotions, and love that people were feeling about ending the war in Iraq: Make sure that when the soldiers come back, you take the same energy to help those soldiers and welcome them back, build off the lessons of what hadn't happened in Vietnam.

Courage comes in a lot of ways and it's not always on the battlefield. Courage comes in being willing to reach out to other countries, to other people, other individuals.

Don't be afraid to be around people who disagree with you. One of the great things about this country is that we can disagree, but we know that in the long run, we share more than we differ on.

Thomas Jefferson said in his inaugural speech, "Let us remember that not every difference of opinion is a difference of principle." We forget that, but it's a really important point.

Peacemaking is not a love fest. Peacemaking is about coming to real, intelligent, and important decisions and accommodations. Find common ground. Start weeding out the differences one by one, not expecting ever to reach perfection, but always working in that direction.

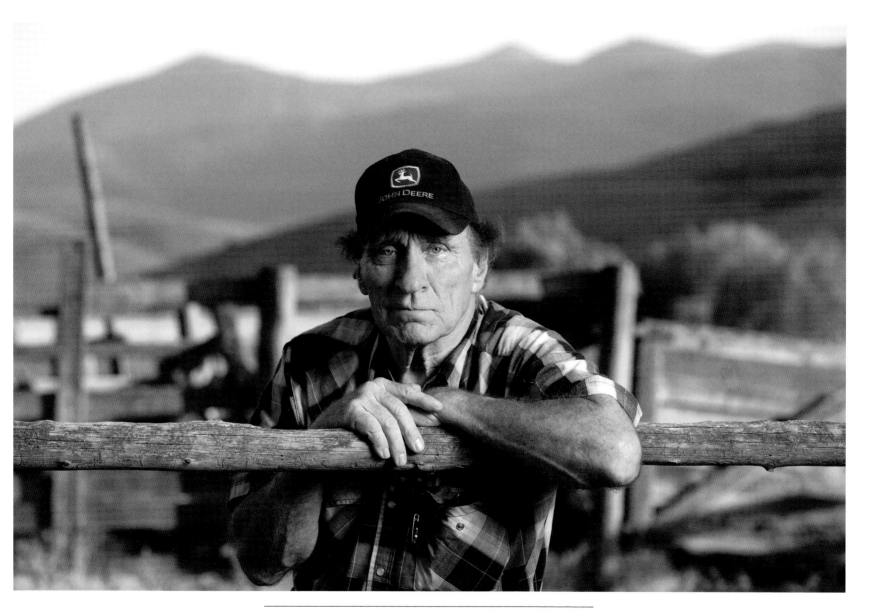

"*We never really had the chance to talk peace with the peace people, the peace advocates, the anti-war people, because everybody was shouting at one another.*"

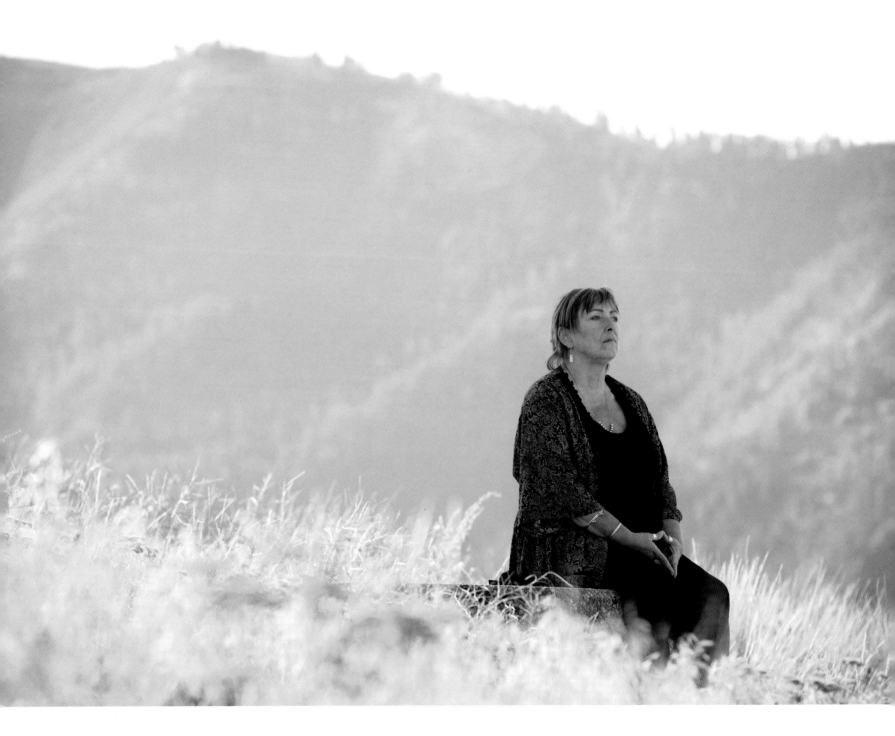

Betsy Mulligan-Dague runs the Jeanette Rankin Peace Center in Missoula, Montana. She is also a Harley Davidson rider, a boxer, and an inventor. She believes it is important to explore different perspectives.

Together, with Dan Gallagher, they found a way to bridge the divide that can exist between veterans and peace activists. They don't believe that divide needs to exist. Their relationship is chronicled in the 2014 documentary film *Beyond the Divide*.

W E CAN ONLY change ourselves. I can't change you. I can't make you do anything, or believe anything, or feel anything. If I operate from blame and judgment, I'm giving you the power to control how I feel, what I think, and how my day goes. I need to focus on what's true for me. What are the assumptions behind my thoughts and values? And what do I want in this moment? If I can focus on that awareness, and learn to communicate that, I stand a chance of getting what I want without demanding it and making you defensive.

I believe that peace is being open to what is outside of yourself. Dan Gallagher [read Dan's story on page 64] is exceptional in that he is open to people who are different from him and think differently than he does.

I had been going to Veterans Day ceremonies. When Dan and I connected and started to talk, we discovered that we had a lot in common. Because we were willing to do that, many people in our respective communities have been willing to come along and follow our lead.

Dan and I don't agree on everything. Dan says, "We can learn from and understand each other without having to agree." He still doesn't like the peace sign, but he's given me jewelry and a little coin that I carry in my pocket with peace signs on them. He understands its importance to me.

I have to be open to other people's opinions and perspectives, because we are different threads that make up this great big tapestry together. Nobody has a corner on the truth. The truth is somewhere in the middle.

We all stumble because we have opinions and we're tied to them. Our opinions come from our experience, our values, and our upbringing. It can be difficult to lay that down and sit in a space with someone that you don't agree with or can't understand. That's what we have to do. We have to say, "I may not be right."

There has to be a connection with my personal peace and global peace. Part of it is my accountability to reflect peace out in the bigger world, and trust that it will grow and ripple out. Part of it is approaching the news and the stories you hear from around the world in the same way that you would approach another person. Be open and delve into the layers. Nothing is black and white. Peace is very gray. Sometimes, even when you think you have it, you realize that there is another step you have to take. I make mistakes. As much as I talk about treating people with compassion, being accountable for our actions, and being respectful, I find myself making a comment that doesn't measure up to any of those things.

It's a privilege for me to work for peace. People say, "How can you do that, because you're never going to get there?" That's the best part of working for something that's so high and lofty and powerful. It impacts and connects us all. I've learned so much about myself by pursuing peace—and teaching, learning, and reading about it. It's a great thing.

Commit to spending time every day with something that you disagree with: read something or talk to somebody that's outside of your circle, go someplace you don't usually go, try to do something that doesn't fit the mold of who you are. Push out of your comfort zone. If we only stay with people who agree with us, we're not making peace. We're just staying comfortable. If we're going to change the world, we have to be willing to get on the edge and push it. Every day take a baby step toward learning something new. These are the things that we need to teach our children.

BETSY MULLIGAN-DAGUE
**MISSOULA
MONTANA**

"We have things that bind us together that we can fall back on when we start talking politics, or something else where we diverge in opinion."

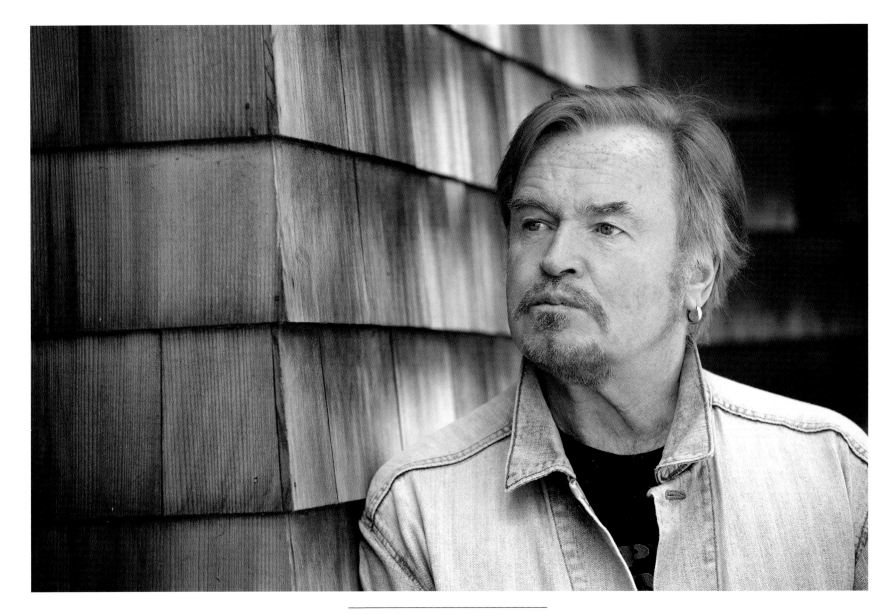

*"You learn about humility,
because you have to start at the bottom
all over again."*

Michael Reid

played bass in a punk band and became addicted to heroin. At first, he used it to get high. After that, it was simply to stave off the effects of withdrawal.

Michael was strung out on the drug for ten years. His days revolved around petty crime to feed his addiction and he got in trouble with the law. His failure to meet the terms of his probation eventually landed him in prison for more than a year. It was enforced rehab and he simply needed to wait for the withdrawal and illness to pass. He made up his mind to stay clean.

After his release, Michael started volunteering at a food pantry. Over time, he was given more responsibility, and now Michael is in charge of a program that feeds more than 400 families each week. The reward is in the faces of the people he helps. The smiles. The whispered thank yous and the grateful hugs at the door.

MICHAEL REID
**SAN FRANCISCO
CALIFORNIA**

I'VE BEEN IN THE MUSIC BUSINESS all my life. Most of it has ended in glorious failure. Very few people actually manage to make it, but it's something I enjoy doing. I would go through it all over again.

In the 1980s, there were a lot of drugs around. Eventually, I ended up in a band with a dynamic lead singer who was a heroin addict. Pretty soon, I followed suit. I blame myself for getting into it. My heroin addiction lasted for about ten years and I lost everything. I ended up on the street and became a pariah. I'd see people I used to know and they'd pretend they didn't know me. I weighed about 120 pounds. I was a complete mess. I didn't have any support from family, so I wasn't able to get into rehab. I had to tough it out on my own.

Eventually, I got busted for possession and put on probation. Then, I got busted again because I never showed up for probation. I was a junkie. There's only one appointment that a junkie's going to keep, and it's not with the court. So I went to prison for 16 months.

That's when I quit heroin. It was the end of the road.

When you are newly sober, you have this euphoria, because your endorphins start working again. You have a two- to three-month period where you feel great, and then all the problems you put on the shelf for the last ten years start flying at you from every direction. That's the tough part, because you have to learn how to deal with that. No longer can you hide your problems by sticking a needle in your arm and going to nirvana.

I've been clean for 20 years. You become older and wiser. You look at younger people and say, "No! Don't do that! It's wrong." But as much as you'd like to impart wisdom, no one will listen, because they've got to see it through for themselves.

In about 2003, I was a caregiver for a person who was mentally ill, and he started coming to the food pantry. Of course, I was summoned to carry his bags. At the time, I was like, "Oh my God, I can't believe this. I have to stand in a food line?" I was really resentful.

I saw these ladies working, and one of them was struggling with a garbage bin that was about to tip over, so I went up and held the bin. They were like, "Why don't you volunteer?" And, of course, you don't want to say no because they were really nice. So I said, "OK."

The first week, I hated it because people were rude to me. "You're bagging the oranges wrong!" "You're doing this wrong!" At the end of the shift, they said, "We'll see you next week, dear!"

I came back the next week to help them set up. And they said, "We're short on people for the open hours. Can you work a table?" And I said, "Sure."

Then you find you're running the place, and you're like, "Wow." You didn't even see it happening. Now I'm actually working for the benefit of others instead of being self-serving. It was a whole new concept.

Families come here to pick up food every week, and they always personally thank us. We get to know their names, they get to know our names, and we develop a relationship with them. People always stop me on the way out and say, "Thank you" and "God bless you." How can you not feel good about that?

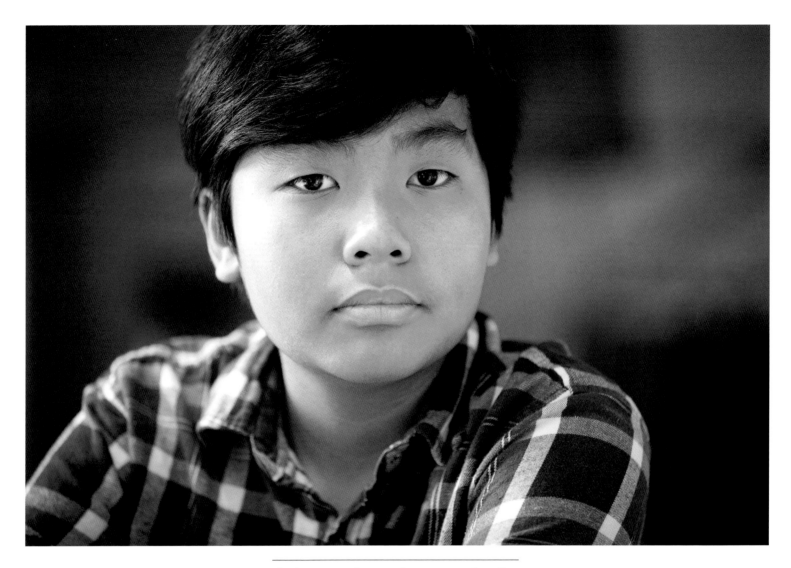

"It's great that we've come this far,
but we should also think about how,
and what, has caused us
to start conflict on the way here."

Jimmy Ta moved from Vietnam to the United States with his mother and his siblings when he was in elementary school, but his father was unable to join them for another year. Jimmy struggled with the language and the culture, and with a lack of self confidence. When a teacher invited him to join a mentoring program called Youth Ambassadors, Jimmy learned that everyone has struggles of some sort and he found a deep satisfaction in helping others overcome theirs. Now a middle school student, Jimmy continues to work with Youth Ambassadors.

He has become a strong advocate for compassion and civic engagement, testifying at the state capitol to support legislation for social and emotional learning, including suicide prevention in an effort to support all youth.

O NE OF THE HARDEST periods of my life was from fourth to fifth grade. I wasn't accepting of who I am, and I didn't like the situation I was in. It was so bad that I even thought about suicide. Then, I snap out of it when I see there are other problems. That I should be really thinking about others, instead of me. The boost that I got was from Youth Ambassador because they make me feel great to work with others and see that everyone has a little imperfection in themselves.

It started from my body. I look fat. I look chubby because I was a bit short.

I started to talk to others, talk to the teachers, and counselors, and they told me their stories. That actually helped me because I know that there's a very hard period in everyone's life.

Everyone, even famous people, have this down period in their life. That make me glad that someday I'll be happy.

Whenever I would feel sad, my fifth grade teacher, Mr. Robert, and my classmate would ask me why I'm sad. If I'm crying, they would ask me what happened. It's helped me a lot because I know that they're actually thinking about me, and they care about me.

Fifth graders work with a partner that is a third grader. I used to work with a little boy. He's silly, but there's a charm in him that made me not mad at him. Mentoring is great. They teach me how to not get mad because someone can't reach the level you're at. That made me think, too.

A kid in another elementary school created something called the Buddy Bench. If you are sad or don't have anything to play or anyone to play with, you would go sit on that bench. If someone sees you sitting there, they'll go talk to you and play with you. It's a compassionate thing to do and it lets kids with social problems or who are [having] a bad day see that others care about them.

To me, there's this emotion inside of me that made me feel glad that someone cared about me and that there's so many nice people in this world. After that, if I see someone sad, I would try to make them happy. Many bad things happened to them, and they can't handle it all, and so I step in and I give them the idea of what the person that helped me, gave me. I would pass it on and make them feel happy. I will be happy to see them help other sad people.

I think if we get peace, if we reach a state of peace, we would remember the kindness, compassion, and sympathy that have been given to us so we can pass it on. Peace is important—to pass compassion and kindness to others.

CANADA

● Seattle

WASHINGTON ID.

OREGON

JIMMY TA
**SEATTLE
WASHINGTON**

ANDREA CANO
**PORTLAND
OREGON**

Andrea Cano trained to be a hospital chaplain in Portland, Oregon after working in journalism and nonprofit administration. She followed her passion to be with people when they are at their most vulnerable, to help them deal with their own suffering and healing.

WE'RE FORTUNATE that spiritual care is being seen hand-in-hand with medical care. As people unfold the sources of their suffering and their despair, essentially exhaling all of that out, they begin to inhale the process of healing. This is what we're beginning to understand. It's not enough just to take an X-ray, or take a pill, or do some kind of a clinical assessment. It's important to move into those other realms of our existence and our being, to come up with possible answers.

When I think of peace, a lot of images come to me. The peacefulness of being held in your mother's or your father's arms, the peacefulness that comes with feeling secure and safe, the peacefulness of journeying together as a community, the validation that happens with folks. I know that peace is challenging to maintain. Peace also engenders different types of emotions. I'm not sure if peace is part of the journey or part of that destination. I think it's at both ends.

In my line of palliative care or hospice work, it comes back to that one individual who is the focal point of great attention. What is his or her hope

for the time that they have, hope that is rooted in years of relationships and love and care, and all those hard, messy moments with families and their loved ones? How does that manifest itself into those wounds? How do we work to ameliorate those conflicts, so that people begin to discern what is absolutely essential and important at that moment?

Essentially, I'm not doing the work, they are. They are into a process of revelation and realization for themselves. A lot of us carry emotion that can't be verbalized, we don't have words for it. We don't even know why we're feeling certain things at the time.

We are not prepared to say good-bye to someone. We don't know how to do it well. The work, again, is to listen to people one-on-one, do some collective sharing, and hopefully folks start to journey from their understanding of their existential questions, or their religious questions, or their spiritual underpinnings.

All we can do is invite. I can't assume who will or won't [accept]. All I can do is be present, extend the invitation, or just follow someone's lead.

For many of us, after 9/11, some things emerged that had us moving toward an element of understanding and peace that we could point to. We were compelled to find community. We were compelled to be together. We were compelled to find out about each other.

We've got to stop drawing the lines in the sand and find moments of being together. I think it takes these kinds of tragedies to come together because peacemaking, for a lot of people, is a very cognitive function. Those tragedies, those moments, touch the heart and spirit, and that's what resonates. That's why we come together. We want to mourn together. We want to find hope together.

I have to be hopeful about brokenness. The brokenness of people who still feel prejudiced against—that young black man who continues to get stopped by police, that Hispanic woman who cleans houses and is paid less just because she doesn't have papers, the brokenness of people who don't have enough to eat in the morning. The brokenness of a word or a look that causes harm. I have to be responsive in some way, shape, or form. The neglect or the refusal to understand that brokenness, for me, is a sin.

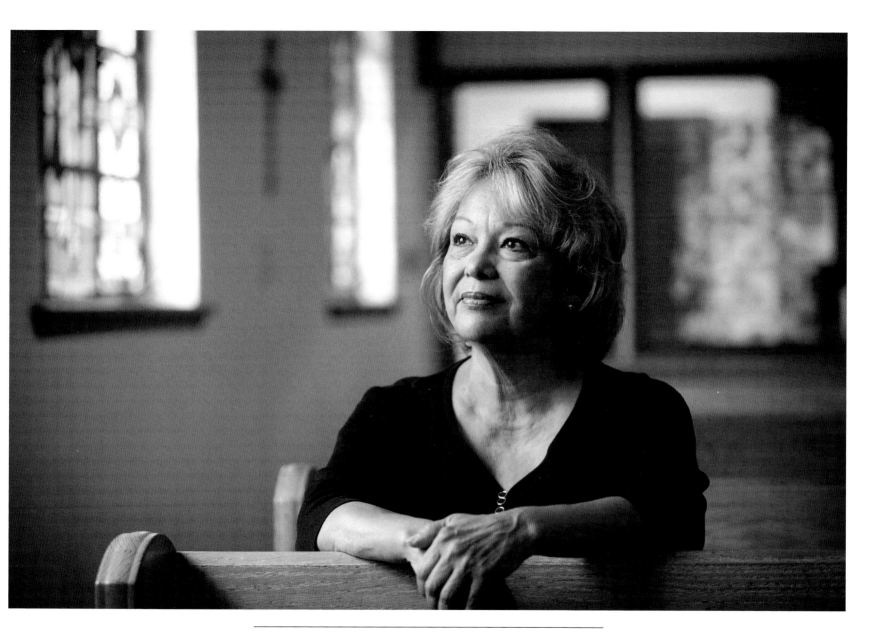

"We become so much about human doings,
we forgot to be human beings."

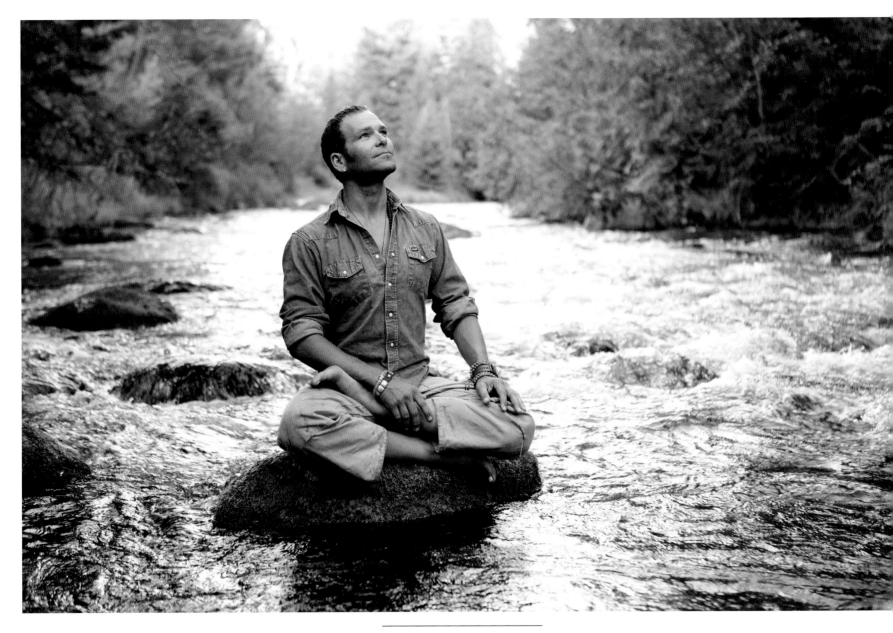

"There was something
that I never knew was missing
until I tasted it."

Brandon Sheehan

was born near Venice Beach, California. He says he grew up with sandy toes and salty lips. He studied fire ecology in college and worked for the forest service fighting fires.

Brandon grew up Jewish, but when he began studying Tibetan Buddhism, he discovered a part of his life he hadn't realized was missing.

Brandon was a resident at the Garden of One Thousand Buddhas in Arlee, Montana, casting statues of the Buddha and helping to create a shrine at the base of the Mission Mountains that is visited by people of many faith traditions.

A T THE GARDEN of One Thousand Buddhas, the big two-story central figure is Yum Chenmo, the mother Buddha. She is the female emanation of the Buddha and has a special line of sacredness. Beneath the statue is the suppression chamber, where things like guns and traps and knives and instructions to make weapons have been poured into concrete. These are things that create violence in the world, but there are also representations of famine, disease, illness, suffering, and sickness. The idea is that people would bring things into this chamber to be consecrated and blessed. They're all in concrete down below that statue, which represents peace or the cessation of warfare. Here we have good over evil, and a world where warfare and hatred and violence doesn't exist.

Yum Chenmo suppresses violence, negativity, disease, famine, and warfare. None of this stuff is particularly Buddhist, it's human.

Many people who visit the Garden of One Thousand Buddhas have no interest in Buddhism, but dig the idea of what is happening there. Whether they're Christians or agnostics or atheists or Buddhists or Jews or Muslims, people come there to pray for or work toward peace. Even people who don't care to be Buddhist want to learn how to meditate, work with their mind, and learn how to be happy.

Inherent in that pursuit is the bodhisattva vow: to think about and do the work of creating happiness for other people. In doing so, I gain happiness. I am the happiest I can be when I've made somebody else happy, when I've offered a smile to somebody who's received it well. Buddhists use the term for warrior frequently. The warrior can be a spiritual or bodhisattva warrior, who continues to work with the struggles, pain, suffering, and internal conflict and keeps on that path of warfare, if you will, eventually to arrive at peace.

No matter what the world is throwing at me, I react with an expression of peace instead of anger, hatred, or desire. That is why this Buddhist stuff is so important to me, because of the opportunities it presents to me in everyday life. When I see somebody that's hungry, or struggling with addiction, when I see my beautiful girlfriend frustrated with some condition in the world, that makes me suffer. That is a lack of peace.

You pull out all the religion and what remains is grace and compassion. You pull out all the spirituality and what's left is love, kindness, and beauty. That might be the spiritual path of all religion, but it doesn't have to be any of them. You pull the religion out of it, you strip it down to its barest level, and what do you have? You've got love, man, you don't have hate. You have peace, you don't have suffering.

If we strip away all that we are as humans, we're left with the essence of goodness, peace, love, and compassion. Some parting wisdom: be peace, be love. Don't be an asshole.

CANADA

● Arlee
MONTANA

IDAHO

WYOMING

BRANDON SHEEHAN
ARLEE
MONTANA

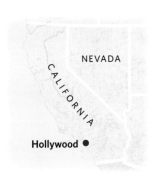

Julissa Arce came to the United States when she was 11 years old and became undocumented at age 14 when her visa expired. She paid for a college education by operating a funnel cake stand and graduated with a degree in finance. Using false papers, Julissa landed an internship at Goldman Sachs, was offered a full-time job, and eventually promoted to vice president. Today Julissa is an American citizen and an advocate for immigration reform.

I HAD AN OFFER to work full time for Goldman Sachs. Instead of being happy and excited about it, I was terrified. It was one thing to be an intern, but it was a whole other thing to work there full time, because I would have to go through a background check. I would have to get trading licenses from government agencies. I thought: My only option is to call it a day, go back to Mexico, and get a menial job.

The other option is to break the law, use fake papers, and ride it as long as I can. I chose option B. My employer never found out that I was undocumented. No one ever questioned me.

If my English isn't very good and I'm working as a waitress or a dishwasher at a restaurant, people are going to question me. But because I was working at Goldman Sachs and graduated cum laude from a top business school, no one was ever going to think twice about me or question my credentials.

Luckily, I was good at my job, built great relationships with my bosses, and had a great mentor. I kept getting promoted and given more responsibility.

A lot of people say, you should have gotten in the back of the line. If there were a line, I would've been waiting in it from the minute I became undocumented.

There isn't a line. I came here legally. Because of that fact and because I married a U.S. citizen, I could adjust my status. A lot of people, even if they marry a U.S. citizen and even if they have children who are U.S. citizens, if they crossed the border illegally, they cannot adjust their status under current laws. There's no way for them to become documented.

Getting a green card allowed me to work, allowed me to come and go as I please. It was such a relief to have those little pieces of paper. In a lot of ways I was free, but I still couldn't vote. I still felt like a foreigner in my own country. I had to wait five years from the time I became a resident to the time I could apply to become a citizen. I guess I wasn't expecting to feel different, because I felt American long before I got a piece of paper that said that I was.

It's easy to place the blame on a group of people who don't have a voice, who don't have representation. That's what is happening. I'm a numbers person. I love economics and finance. How is it possible that we can blame 11 million people for all of our problems? However, politicians do that every single year. Immigration is at the center of the political debate, but not for the reasons that it should be.

Eleven million people currently cannot live as full human beings. Eleven million people are scared every day of being separated from their families. If they're driving down the street and get pulled over, they will be deported. I know what's it like to live with that fear. That should be at the center of the conversation, because it's a human rights issue.

When I talk to people who are undocumented, they tell me how little peace they have. I found peace long before I became a citizen or a resident. The first thing I do every day is write in my journal the things that I'm thankful for. Today I'm thankful that I woke up, that I have an apartment, that my mom is healthy. Then, even if I have a bad day, I go back to thinking about the things that I'm thankful for. I believe that it's in gratitude that you find peace.

Sometimes we confuse peace with never being angry or having any negative emotion. I don't think of peace that way. Peace can exist in the middle of chaos. I get mad. I'm frustrated, I obsess over things. But at the end of the day, peace is beyond a feeling or an emotion. It's what's under all of that. Just be thankful. Think of one thing that you can be thankful for every day.

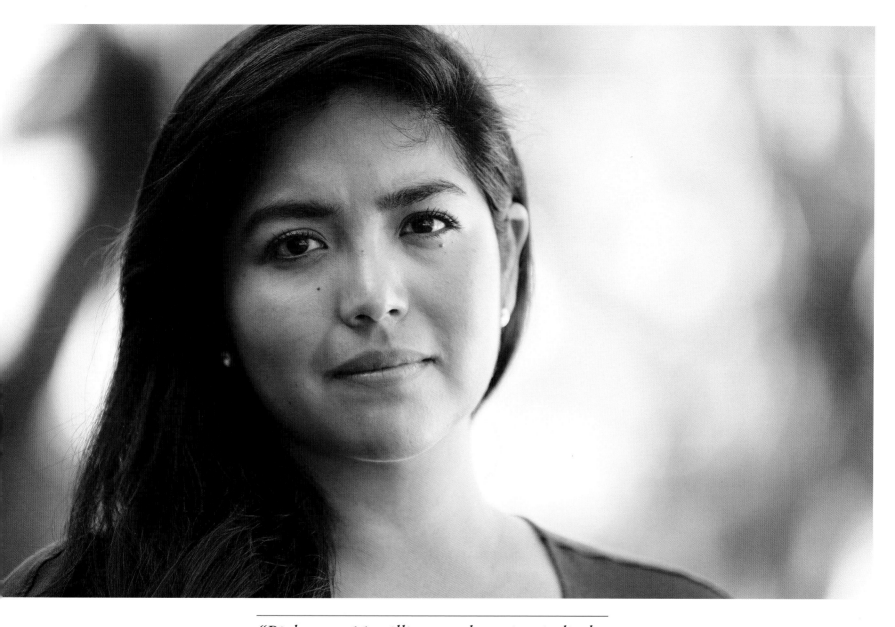

"*Right now 11 million people are just in limbo,
that's why immigration should be at the center
of the conversation. We should be thinking about the
people who are affected by the inaction of our country.*"

Chris Brixey

works as a paramedic, a ski patrol, and a wilderness EMT. He says that's how he puts bread on the table and beer in the fridge. Some of Chris's earliest and fondest memories are of pulling into a campground with his family and spending time outdoors. He says that a lifetime of satisfying experiences in the mountains have driven him to want more.

CHRIS BRIXEY
**LEAVENWORTH
WASHINGTON**

"We'll never eliminate all the bad ideas, bad people and bad actions, but we can reduce their influence by just choosing to focus on the positive, which isn't burying our head in the sand."

THE MOUNTAINS have always been my church. Life is simplified in the mountains. We feed ourselves. We clothe ourselves. We move ourselves by our feet. We help our friends get up the mountain and get back down. We work as a team. Whether I'm there as an alpine guide or as a paramedic, I find it spiritually satisfying to be in the mountains.

When I'm in the mountains, I'm at peace. Maybe I'm not at rest, because it's a lot of work, but there's definitely a peace that I don't find elsewhere.

A sense of exploration drew me to alpine mountaineering. It's not only the landscape around me, but the landscape within me that I explore in those moments. I'm aware of my breath and of my body moving through difficult terrain, whether it's steep snow or vertical rock.

It's important that we take moments throughout our lives to examine our character, actions, motivations, and thoughts. Test them.

Evaluate them. Are they working? Are they producing the results that you're looking for? Everyone's looking for peace, balance, satisfaction, and worth. If I'm not finding those things, how can I change? How can I improve myself?

When I'm in the mountains, I find moments to reflect on that. I check in to see if my life is working out, to make sure I'm part of the solution and not part of the problem.

Our actions and thoughts have consequences. If we dwell in the negative, it has negative consequences. That's an easy default for a lot of people, but if I choose to turn my thoughts toward the positive and embrace that more often, it brings a balance within me that affects the people around me.

When people fill their heads with negative images, it brings them down. It undermines their trust. It puts a burden in their soul that man is essentially bad, and that there is evil in the world. Doors close, window shades get pulled down. Eyes are averted. There's less connectedness. That's the consequence of filling one's life with negative imagery and thoughts, whether it's conscious or unconscious.

I fear that that's where we are as a society—particularly in the United States. We've got this amazing form of government, but right now, for reasons I don't completely understand, we seem to be missing the mark. We're not focusing on the right questions anymore. We're looking at the things that divide us. We're selling fear and people are buying it. They think it's for all the right reasons, and it's not.

Every action has a root cause in either fear or love. All that energy in your head, all those voices, all that vibration, it goes out and it affects the world around you—physical, mental, and spiritual. It impacts every thought and every second. How do you shape the world? How do you envision it? That's how change happens.

We're not trying to change. We're trying to channel the change. We're on a river and it's flowing. We've got decisions to make. There are eddies over there, rapids over there, and some slack water there. There's a big waterfall that we've got to maneuver. We've got choices to make. Never stop believing that your choices matter.

"I just believe they have preconceived thoughts
about what black people are.
And they act upon fear."

Rashaad Arnold is a social worker for a nonprofit agency in Portland, Oregon. He is a caseworker for foster child care. In his free time, he writes and records rap music under the stage name Shorty Spade. He describes it as "music you can play in front of the entire family."

Rashaad remembers having "the talk" with his parents about what to do if he were ever pulled over by a police officer. Although he has never been cited for more than a parking ticket, Rashaad has been pulled over multiple times for what he calls "driving while black."

RASHAAD ARNOLD
**PORTLAND
OREGON**

To ME, PEACE IS LIVING FREELY without disruption in your daily life as long as it doesn't cause harm to somebody else. As a nation, as a world, I don't think we're good at that.

I work toward peace by giving the same respect that I get. I'm not an activist, but I do give peace and I am a peaceful person. I get involved with other like-minded people and I try to produce the same outcome. You get what I am saying?

There aren't a lot of African Americans in Portland. People think you are what's portrayed on TV. They think you're either a thug or a gangster. There's been plenty of times I'm just walking down the street and a white lady will literally walk across the street instead of walk past me.

You can't let it get to you. You just let it go. You'll walk past somebody's car and they'll lock their doors, and you just look over like, no one's even thinking about your car. But it happens, because they just don't know. People have their preconceived conceptions of what you are and what you're going to be like. So you're the stereotype.

I hung out with everybody in high school. I hung out with the Hispanics. I hung out with the Asians. I hung out with my African American friends, and I hung out with the white kids. And the Asians and the Mexicans would always say, "You're not like other black people." Even my white friends would say that. And in high school, I was just like, "Oh. OK, thanks." I didn't know what it meant. Now that I'm in my mid 20s, I understand what they meant. And I should have corrected that right then and there. I could've told them not all black people are criminals like you see on Law and Order.

They have to come out of their bubble. Go to the West Coast, go to Chicago, go to Detroit. Get out of that bubble and see what the world is really like.

PEG CARLSON

**HOLDEN VILLAGE
WASHINGTON**

"The beauty of art has always been that it doesn't use words. The visual arts give us another way to communicate with each other without actually having to talk to each other."

Peg Carlson is codirector of Holden Village with her husband, Chuck Hoffman. Holden is a faith-based intentional community nestled in a remote valley of Washington's North Cascades, accessible by a 30-mile boat ride and a 10-mile gravel road. Prior to Peg's five-year commitment to lead Holden, she worked as an art director for Hallmark Cards in Kansas City.

Peg and Chuck create art around conflict and healing. They lead creativity workshops with people who have historically experienced conflict as a way to build relationships.

I'VE BEEN INVOLVED in places of conflict and I've been involved in places where people were trying to find peace. People come to Holden to find a part of themselves that is grounded and true and connected. When I think of peace, I think of connections and I think of relationships. Wherever we go, people are telling the same story, the need to belong and be loved, the need to care about and connect with each other.

Holden is sort of connection on steroids. Every day is an opportunity for conflict and an opportunity for conflict resolution. It's about the rhythms of daily living. There are opportunities to experience conflict with each other just because of the tight quarters. There is nowhere to go in Holden. You can go hiking, but eventually you have to come back because there's nowhere else to get food out here.

When Chuck and I started working in conflict resolution, we had an opportunity to paint a very large painting, and we did not have time for either one of us to do it by ourselves. We painted it together, and we found the painting didn't look like what Chuck would paint and it didn't look like what I would paint. It looked like a third thing— something that neither one of us could have come up with on our own. We had a moment of, "Oh my gosh, that's what it means to have some sort of resolution."

In a way, that's what peace means. It's not a compromise, it's a new idea. It's something totally different. When we direct here at Holden, we have Chuck's ideas about what we should be doing, and we have my ideas about what we should be doing. Usually, neither one of those is just right. We work together and get all of our information on the table, and it's usually a third idea that is the most amazing thing. It happens with people, it happens in artwork, and it happens any time people come together and really share their hearts.

That's what has to happen on the planet. We can't be in our own little boats rowing around and avoiding each other. That's not going to work. It's in the in-between space that there's something to be mined, to be discovered. Something else that you didn't know was there. I love that.

Peace is a big word that describes so many things. After working in and around that word for quite a while now, it's getting smaller. I used to think of peace in the world, between nations, between big entities. Then it got a little smaller and tighter. And now, instead of peace being something out there that we had to find, or achieve, or do, or make, or facilitate, it's something inside, to grow and nurture and pay attention to—like a little flame that burns inside of you that you give oxygen to.

It all boils down to love and making room for love. We all have that flame of love inside, but we get too busy. We have our own agendas, and we have our own ideas of what we want to do with our lives and with the people around us. But Holden gives us space to push away some of the things that crowd in around us every day, and just consider that love is at the center of things.

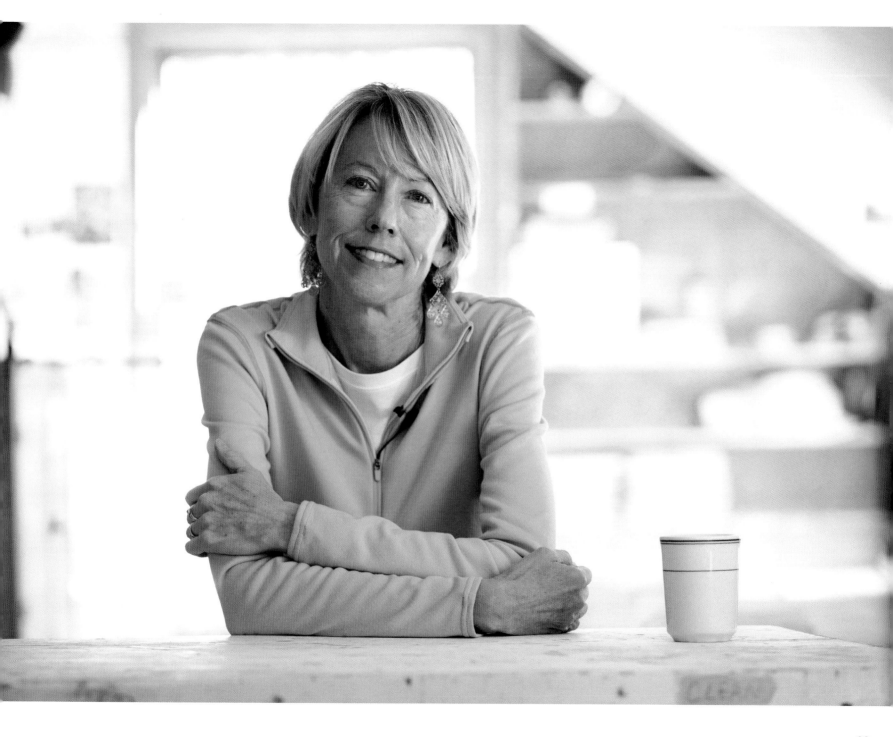

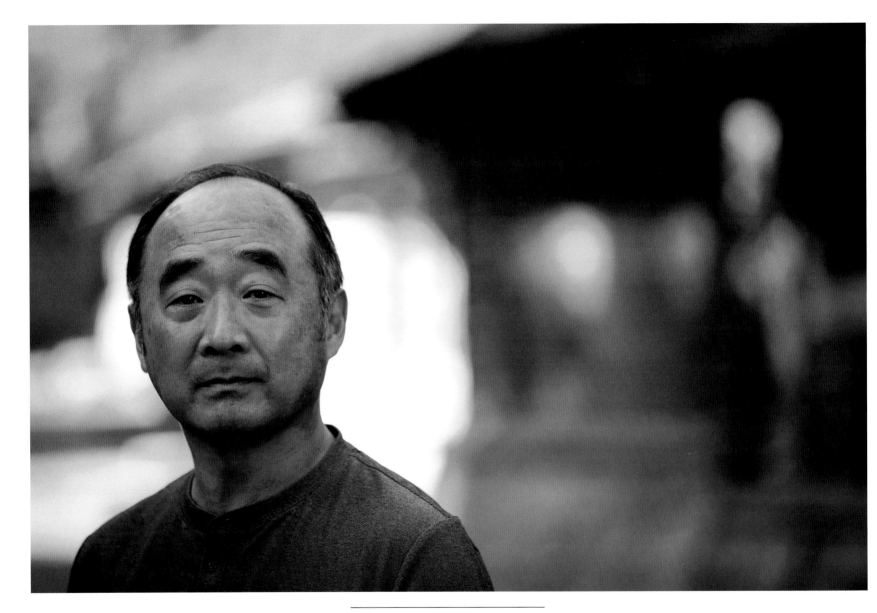

"*At times of fear, people do irrational things that they would never do any other time.*"

Clarence Moriwaki is founder and past president of the Bainbridge Island Japanese American Exclusion Memorial in Washington State. It is the site where the first Japanese Americans were taken from their communities and put into concentration camps during World War II.

In total, 120,000 people of Japanese descent were placed in concentration camps on U.S. soil when the Pacific War broke out. The first 227 people—two-thirds of them American citizens—were rounded up and removed from Washington's Bainbridge Island on March 30, 1942.

Decades later, in 1988, the United States would formally apologize for the internment, acknowledging that there was no military need for the removal and that the actions were based in fear and racial prejudice.

CLARENCE MORIWAKI
BAINBRIDGE ISLAND WASHINGTON

BAINBRIDGE ISLAND is an incredibly peaceful place. Because it was a small island, everybody worked together. There wasn't a bridge. You had to get along with your neighbors. And because the children went to school together, all the races mixed. Swedes, Japanese, Filipinos, Norwegians—people got along and got together. It was an example of what America is supposed to be, a melting pot of cultures.

Then the war broke out and there was an incredible divide. It brought out the worst in us. It brought out fear and racial prejudice. It was a little different on Bainbridge Island. On the day Pearl Harbor happened, Walt and Millie Woodward, publishers of the local newspaper, editorialized that war had broken out, but cautioning that these are our still friends and neighbors.

President Roosevelt signed Executive Order 9066 on February 19, 1942. It set in motion a forced exclusion. A month and a week later, Civilian Exclusion Order #1 was posted all over Bainbridge Island. It said: All people of Japanese ancestry will be taken away in six days.

When Roosevelt signed that order, Congress was either mute in its acceptance or goading him on. People who opposed the order were noticeable because they were the exception.

Yet when we started this project to build a national historic site, we had unanimous votes every time. Our city council on Bainbridge Island supports it and the county commission, but the state legislature also unanimously supported this project. East, west, urban, rural, red, blue, every corner of the state said this should happen. Contrast that with 70-plus years ago when it was the other way around. It's an incredible thing that time can heal.

Civilian Exclusion Order #1 was only for Japanese Americans. Executive Order 9066 allowed movement against any enemy in the United States, but there were no civilian exclusion orders for Italian Americans or German Americans.

Our motto here is *Nidoto Nai Yoni*, which means "let it not happen again." That's our hope. Learn from the past, and be inspired not to let it happen again.

On September 11, 2001, we were glued to the TV. The first thing that went through my mind was "I'm worried about my Arab American and Muslim friends." There was a newsflash. They said they were going live to a mosque in north Seattle. And I thought, "Is it on fire? Is it defaced?" It was nothing of the sort. The interfaith community of Seattle made a human wall. They guarded this mosque with their bodies 24/7 for days to prevent exactly what I was afraid of. I cried. I couldn't believe people had the courage to do that. These are eternal stories. We have to continue to tell them so we can overcome the fear and racial prejudice.

The opposite of love isn't hate, the opposite of love is fear. We are still in a War on Terror, and our civil liberties are being forgotten. For many Arab Americans and Muslim Americans, the story's not over. We must be vigilant.

In order for there to be peace, a country must be strong and its citizenry must be strong. People must speak out when the government says something wrong. This is something we should teach our children. When a person is getting picked on by a bully, that person is being violated. Stand up for them. There's an entire group of people in the United States who were violated 70 years ago. Very few Americans stood up for them. So I hope this site informs people about what has happened in America. If you're not vigilant, it can happen again.

Ray Padre Johnson served as a medic in the Vietnam War. He worked as a cowboy on ranches in Wyoming's Wapiti Valley, outside of Cody, and it was there he discovered his love of painting.

He spent a dozen years traveling the world, pausing in communities in 159 countries, where he ate with people, danced with them, and got to know them. Padre painted the portraits of more than 500 people from around the world and assembled them into a book and an exhibit called *Journeys with the Global Family*.

THE FIRST PRIORITY IS TO LISTEN and to give the same respect you have for yourself. Our responsibility is to pass on the good and to listen to and enjoy each individual. No one will ever look like we do, or even think like we do. The events and influences that have shaped our sight, and the lens through which we interpret them, are different from anyone that will ever occupy a piece of ground on this planet.

You never know when you're going to be an instrument of acceptance, of goodness, of caring, of being there with your presence. That's enough. You don't have to say anything.

The last time I was in Harlem, when I was on my journey around the world, I told my cab driver, "I want you to leave me off at this corner." He looked at me like I was from another planet. He said, "I can't do this. I'm not going to leave you off down here. I think you're probably the only white man around this area." I said, "Leave me off." I had already been through the Vietnam War and I had been through about 85 percent of my journey around the world, meeting with people from all religious, ethnic, racial, and cultural and family backgrounds. I was comfortable. "Leave me off."

I said, "If I don't get back to you, you know I crossed the bridge prematurely to heaven." He couldn't help but laugh. He said, "You're crazy." I was standing on the corner and immediately I was surrounded by four men, of a different color. [One of them asked,] "Hey man, what are you doing down here?"

I said, "Gentleman, I am a real-life cowboy from Wyoming and I'm down here just to enjoy you and to learn. If you don't mind, I'd like to hang around."

"Are all cowboys like you?"

"No. We all wear a different fingerprint. I'm an artist, also, and from my view, you're all wearing a different color, a different nose shape, a different eye shape, a different mouth shape, forehead, cheekbones. I see us all as uniquely different, but similar. I celebrate both of those. No one will ever look like you again. No one will ever think like you. You're that important. You're that unique a person ever to walk this planet. I give you the same respect as I give myself."

"We have a bunch of friends, would you come with us? We'd just like to sit and talk shit."

The next thing, I'm with about 15 guys, and we're just ragging on it. I'm staying over night and eating with them and enjoying them. Of course, they said, "Why can't more white people be like you?" I said, "You come out with me to Wyoming, I'll show you a whole carload. You'll have the best time and you can stay with me and you can ride my horse."

We were having fun laughing. Those endorphins were flowing and adding about three years to each one's life.

All over the world, everyone wanted me to stay because they could see I'm an explorer. I'm an adventurer. I'm always seeing worth inside of that next human being that is so different than anyone else, and yet, so similar. I celebrate that in my my art. People see the subject's enjoyment—and a smile on almost every one of the 500 faces I've painted.

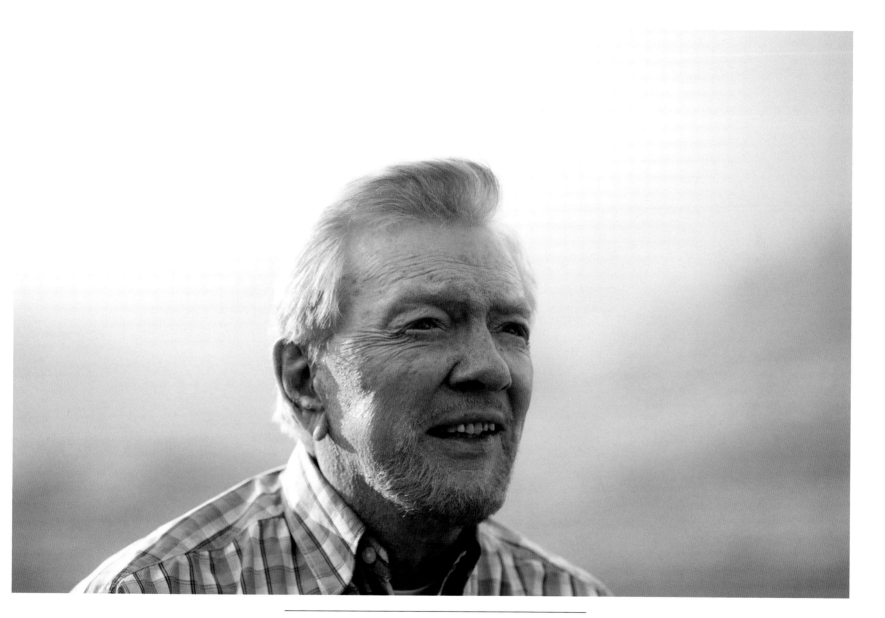

*"You never know when you're going to be
an instrument of acceptance, of goodness, of caring,
of being there with your presence. That's enough."*

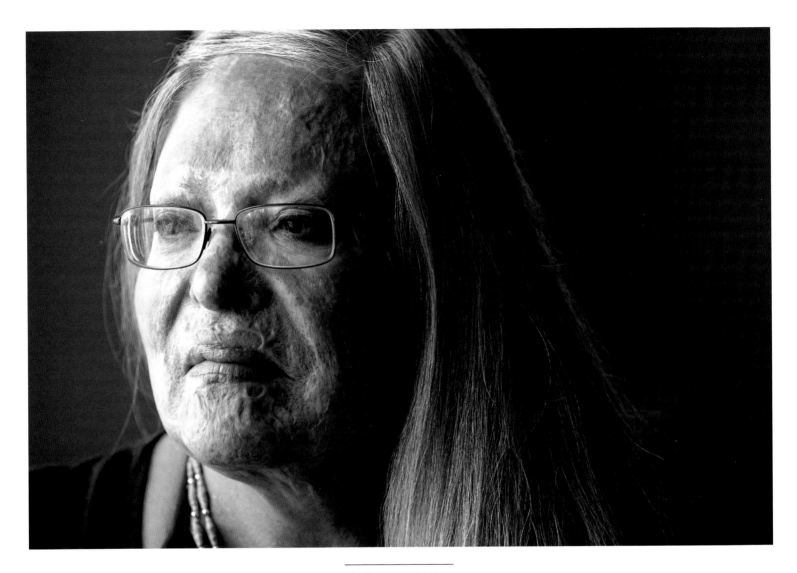

"I learned that
beauty came from the inside,
not from the outside."

Benita Alioth moved back to her childhood home just before Christmas 2007 to care for her aging mother. On October 22, 2008, she woke to her mother's call for help. The house was on fire. When Benita tried to pick up her mom, they both fell to the floor and were engulfed in flames. She wasn't able to save her mother.

Benita was in a coma for 12 weeks. The hospital told her she had second and third degree burns over 48 percent of her body, though she thinks it must have been more than that.

At the time of the fire, Benita was divorced from a Vietnam War vet, who suffered from PTSD. Benita says she never understood his struggles, until she suffered her own trauma.

BENITA ALIOTH
PORTLAND
OREGON

I FORGAVE MY CHILDREN'S FATHER. He passed before I could tell him to his face that I was sorry and ask if he could forgive me for my shortcomings. I didn't understand and I didn't care to understand. I was very selfish, very self-indulged. It took what happened to me to get the spiritual feeling I have now.

I'm a lot more mindful. I've learned how to slow down and listen. Before, what was important to me was what I looked like on the outside. I always had to have my makeup on and my hair combed. I learned that beauty came from the inside, not from the outside. I have friends that still tell me, "Benita, don't you understand? We've always loved you for the person you are inside? Do you know how beautiful you are?"

I know that I'm a burn survivor and I've got flaws now. I don't have this perfect image that I thought I had before. Self-indulgence can eat you up. Now I'm thinking more about how other people are doing. I volunteer at the hospital as a burn survivor. During a family's darkest hours, when their loved ones are in ICU fighting for their lives, I can walk into the waiting room and talk to them.

They've never seen a burn survivor. I know I'm giving them hope. Their loved one might not be exactly as they were, but there's hope. They can continue with life in peace.

I can't express enough that until something tragic happens to you, it's hard to see what's coming from someone else. When that lightning strikes, it makes you vulnerable. When you have that vulnerability, it seems like your eyes open up to others who have vulnerability. You can see it.

Through this whole experience of all the pain and healing, I have become a more spiritual person. I'm dealing with each day as it comes. I believe that some good will come out of all the things that happened. I've learned that I can still look forward to some goodness and I've learned to be more humble. I've learned to listen to people. I've learned to accept people for their conditions. I learned that every day is a gift. Every day, I'm grateful to be here.

I started writing after the fire. I wrote a poem called "Inside Out." It describes how I feel as a survivor.

Inside Out

I'm not a victim of circumstance,
I call myself a burn survivor.
Born again.
Though I wonder why.
Do they pick a number like a lottery?
Maybe look you over on the side.
You are needed. You will survive.
Take my hand. I'll be your guide.
Could it be some wonder that I could be the best?
I still mourn for what was then,
that outside beauty so, so hard to beat.
Then I pray to God, I tell him,
"Please, be patient." Give it a rest
for I know I need to learn to love me
from the inside the best.

the southwest

KANSAS

Oklahoma
City
●
OKLAHOMA

TEXAS

BUD WELCH
OKLAHOMA CITY
OKLAHOMA

Bud Welch lost his only child, Julie Marie, in the Oklahoma City bombing in 1995. She had worked as a translator in the Alfred P. Murrah building for just five months when Timothy McVeigh and Terry Nichols blew it up in what remains our nation's largest domestic terror attack.

Following Julie Marie's death, Bud was despondent and angry. He began abusing alcohol and tobacco. His businesses struggled, and he wanted nothing more than for McVeigh to be tried and executed for his crimes.

But when Bud saw a news clip of McVeigh's father, he saw a man who was as lost and broken as he was. Eventually he reached out to Bill McVeigh and had coffee with him at the McVeigh family home.

The two men became friends, and Bud Welch began to work against the execution of Timothy McVeigh, having realized that his healing process—and his sense of peace—would not involve the death of one more person. Despite Bud's efforts, McVeigh was executed on June 11, 2001, but Bud has gone on to work against capital punishment around the world.

BILL SAID, "BUD, CAN YOU CRY?" I thought, why is he asking me this question? And I said, "Yeah, Bill. I can. And I don't have much trouble doing so." He said, "All of my adult life, I've been unable to cry. My father was much the same way. I've had a lot to cry about the last three and a half years, but I just can't do it."

After a long silence at the kitchen table, Bill looked up at the wall and he said, "That's Timmy's high school graduation picture." When he said it, a great big tear rolled out of his right eye down his cheek. This father could cry for his son. It helped me tremendously to meet him and go through that stage of what I call restorative justice. At that moment, his son was in Florence, Colorado, on death row. And I didn't want to see him die.

On June 11, 2001, a Monday morning at 7:00 a.m., we took Tim McVeigh from his cage in Terre Haute, Indiana, and we killed him. There was nothing about that event that brought me any peace. In fact, I felt revictimized. After that day, Bill McVeigh and I had one thing in common: We had both buried our children. They died in very different ways, but we had both buried our children.

Before Tim's execution, I started feeling like I was forgiving him. It's a process and it takes time. I don't know how to teach that, but I know that I went through it. I can tell you one thing: Forgiveness doesn't do a damn thing for the killers. You totally release yourself. That's where the good comes from.

"That's
the big lie that
family members
are told.
That once he's
executed
then you'll be
relieved and you
can go on.
Just the opposite
actually happens."

*"You know, if the horse doesn't want to cooperate today,
we just stick with it.
It's like rearing children, I guess."*

Hassan Ikhzaan Saleem

was born in the Maldives, a tropical island nation south of India. Raised in a family that encouraged reading western classic literature, Ikhzaan fell in love with the American West and the idea of working with horses.

Ikhzaan attended United World College in Montezuma, New Mexico, and lived with a family that owned a ranch. There, he learned to ride horses, but also how to train them in the Vaquero style, with a focus on patience and an absence of strict deadlines.

While working with horses, Ikhzaan recognized that our days can be filled with challenges and frustrations, but each new day presents the opportunity to begin again. If we can let go of yesterday's failures and focus on today's opportunities, we can feel at peace in the knowledge that we tried even if we are not able to reach our goals.

I WORK WITH THIS RED HORSE, Caspian. We work and we get things done and I'm so proud of myself. I come back next morning and he's forgotten everything or I've forgotten everything, and it doesn't work. It's hard to be calm at that moment.

I get frustrated. I get mad. But tomorrow is a new day. All is forgiven.

When I was getting into horsemanship, a great cowboy and horseman said to me, "If humans were like horses, there'd be more peace on Earth. A wild horse, a feral horse, is being chased by a mountain lion. It's running 100 miles an hour and the mountain lion gives up and lets it go. The horse doesn't just stop and go back to grazing. The horse stops, gets down on the ground, and rolls in the dirt. It makes a transition."

If humans would take the time to make the transition between their lives when they're doing things, there'll be more peace on Earth, he said. I've always remembered this, and I try to apply that to my life.

If you get mad today, don't carry it with you for the rest of your life. Take the time to transition. Come back home, calm down, relax, enjoy your company. I try to do that. So whenever you get frustrated, it's OK to lose it, but just remember to transition out of it. Forget everything at the end of the day. It's done.

People have got to live together. It's your responsibility. In a sense, everybody's your brethren. It doesn't matter if you're from the United States or the Maldives. These imaginary lines on maps and these pieces of paper that say you are this and I am that, it doesn't matter, because we're all the same. We have a relationship with humans, the four-legged, the trees, the earth.

I'm not Mahatma Gandhi. I'm not Martin Luther King Jr. or Nelson Mandela. My parents said to me, "You might never change the world and you might never see the change you want to see, but at least you tried. At least you can be accountable." So that's why I try.

Even with horses. People say, "Aw, you've been working with this horse for six months, he still sucks." And I say, "Well, I'll keep trying, and one day that horse will be great and I'll ride him in the biggest rodeo. I'm going to take him up in high country and pull a steer, and it'll be the most beautiful thing in the world."

And that's the goal. One day, there will be peace. Maybe I'll not live to see it, and maybe my kids won't live to see it, but we tried. That's why we do it again and again.

HASSAN IKHZAAN SALEEM
SAPELLO
NEW MEXICO

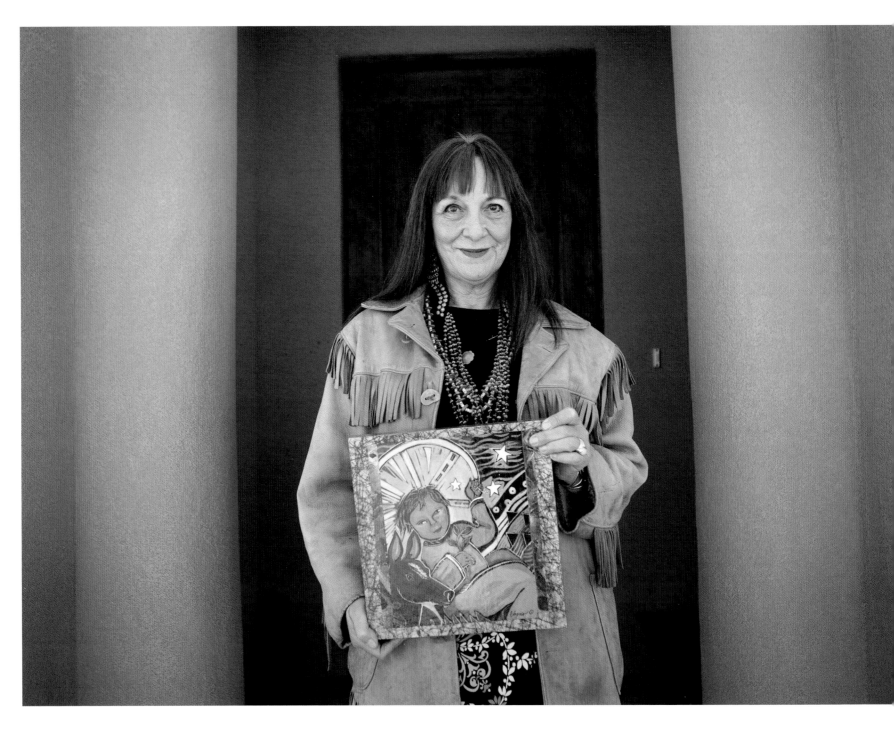

Amy Cordova sees her work and her life as inseparable. She is a visual artist, writer, and educator based in Santa Fe, New Mexico, where she works with students from preschool age to 99 years old. Amy has been creating art for as long as she can remember and finds the combination of art and nature to be transforming. She sees hope in children and her work calls on adults to wake up to the wonder, beauty, and potential that she believes young people embrace intuitively.

THERE'S ENOUGH SORROW and sadness in the world. I choose for my own work to be uplifting because that makes people feel some kind of a connection. That's the goal of what I do because at the base of it all, it's just love, and respect. That's what everyone wants.

I find that my strength comes from the earth. That's where I find solace and strength and feelings of belonging.

Personal peace, I believe, is in the moments when we feel connected, protected, and satisfied, and there's nothing lacking. Personal peace is where we have to start, and maybe it will never get beyond that in the world.

I'm sorry to tell you, but I don't know if peace could ever be attainable in the world, because there are so many different perspectives and there are so many agendas that want to dominate or profit from others. I can try to have a good heart and be open to people. There's a calmness in being centered within myself and how I walk in the world.

I do lots of residencies and workshops. I've worked in prisons. My motivation is to find that little spark that is in you, even though you may not believe it exists.

I was working in Minnesota at a prison for juvenile offenders—felons—and it was interesting to me because when I first came in to the classroom, everyone was pushed back in their chairs with their arms crossed and just staring. After about three days, it totally turned.

We read a book called *Bearstone* about a boy who's run away from some kind of a situation. He ends up in a cave and he finds a fetish of a bear. The bear is a great healer, because he goes to the roots of things. He's a dreamer. He goes in his cave to dream of the trout and the blueberries.

Then they made their own personal bearstone out of clay and painted it. One boy came to me afterward, he's probably about 17, and he said, "You know, my whole life, I've only been told what a loser I am and that I'll never be anything." He said, "Look what I've done, I've made something."

They wrote about dreaming in the bear cave. I thought confinement was like being in the cave for a period of time. Instead of being despondent, it's a time to configure your world and discover what your dream will be.

I'm not against technology, but I feel like sometimes we have too much information. I don't know how we can resolve all the horrors in the world. I don't have the answer. I wish I did.

We do what we can on our level, whether it's talking to a child who's crying, or trying to engage the world in things that can help lift us all up and see each other with new eyes. That's all I know.

My work saves me. Music saves me. The landscape saves me. The water saves me. Instead of letting those difficult things permeate us, we have to let them roll off.

UTAH COLORADO

ARIZ. Santa Fe

NEW MEXICO

TEXAS

MEXICO

AMY CORDOVA
SANTA FE
NEW MEXICO

"When I write I want to make pictures with my words and when I paint I want to tell a story."

UTAH COLORADO

● Shiprock

ARIZ. NEW MEXICO

TEXAS

MEXICO

EUGENE JOE
**SHIPROCK
NEW MEXICO**

*"Your creator
gave you
a special tool
in your life.
To find that
is to learn how
to face the reality
of life."*

Eugene Joe is a Navajo sand artist who lives near Shiprock, New Mexico. At an early age, Eugene's grandfather helped him discover his gift of art. His grandfather would send the boy to meditate on a nearby hill and say, "You have a gift that's inside of you. Go there and find it."

At first, Eugene could only notice the insects that would crawl on him and the sun that would burn his skin. But eventually, the distractions fell away and Eugene was able to focus on his task of discovery. It was then that he began to draw in the sand where he was sitting and recognize his love of sand art.

A LOT OF PEOPLE ask me, "How did you find your gift? How did you know you had talent?" And I say, "You don't find your gift overnight." Your elders are great teachers. They guide you into your manhood or your womanhood.

That was part of my grandfather's task with me. In the time of wagons and horses and dirt roads, my grandfather used to tell me, "Go on that hill."

That's where my discipline began. At the time, I was barefoot all the time, wearing an old dirty T-shirt and running around my grandfather's estate. He told me to sit out there and meditate and focus on my life. He told me, "You have a gift that's inside of you. Go there and find it." And I said to myself, "Out here in the desert?"

He told me, "Always focus on going forward. Never look back until there's white hair on your head." I didn't know what he meant at the time, but later, I began to understand.

And so I would sit up there, maybe for three or four hours. My first task was to ask myself, 'What am I doing here? I'm a child. I'm supposed to be out there playing with children."

Black Elk said our children were mature when they were the age of 7 and they were men at an early age. And so we teach them to be disciplined, to become men, to face the reality of life.

Sitting there, the first thing I thought about was that I was afraid of ants, spiders, snakes, scorpions, and centipedes. Before I left the wagon, my grandfather said, " Don't think of things that surround you that will interfere with you. Focus. Focus on yourself. Don't look at the ants. Don't look at the centipedes. Don't feel the heat that burns your skin. Become one so you learn how to face what surrounds you. And learn to overcome those fears."

Sitting there on the hill, I began drawing on the earth—and there was the gift. That's why I'm a sand artist. It was set before me. All I had to do was reach out and walk into it.

So I guess that could be true of any obstacle we face in life. My grandfather said, "Do not rush yourself. Always walk with the sun." So what does this proverb from my grandfather mean to me? Don't get ahead of yourself. Enjoy life and absorb nature and be thankful that you have a wife, children, and a home. In other words, we don't need to rush into the future.

Everything is up to you. If you want peace in your life, you have to make that peace. If you want to be successful, you have to make that happen. If you want an education, you have to make it happen. It's up to us, up to the whole world itself to become one again. That's how I see it and I believe in that.

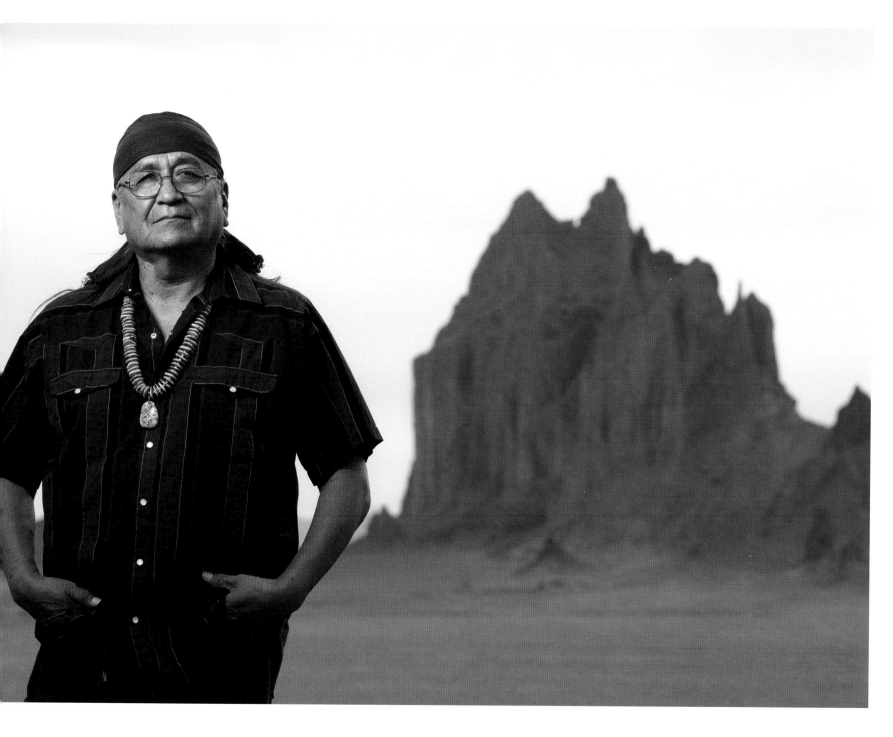

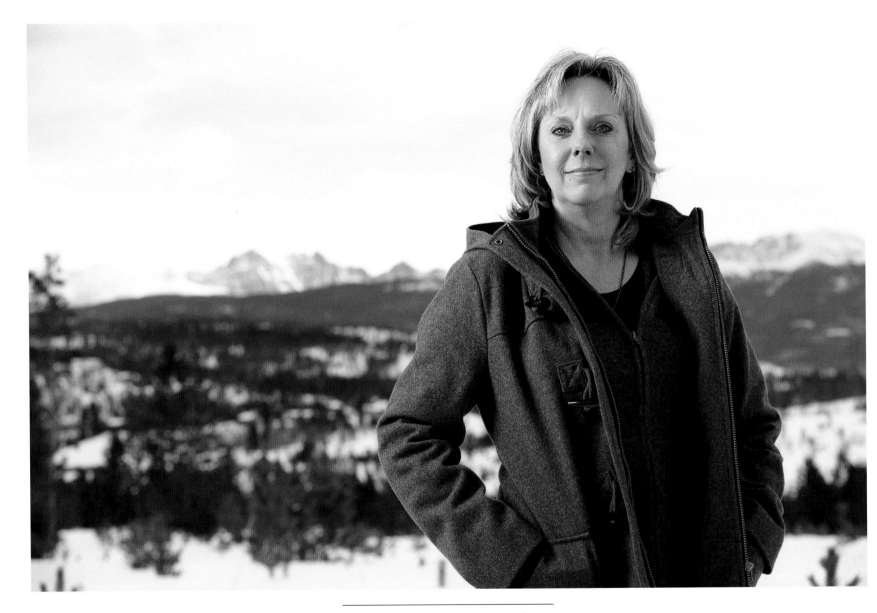

"It's powerful when you have
the opportunity to be still
and reconnect with who you are."

Heather Ehle

Heather Ehle is executive director of Project Sanctuary, a program designed to help military families heal. With no military background herself, Heather volunteered at a free clinic during the first Gulf war and saw military families struggling to readjust to civilian life after deployments. She now coordinates retreats, centered in Colorado, to reconnect families and give them support to thrive.

Heather describes herself as politically agnostic, which she defines as "having been to Washington one too many times."

WYOMING NEB.

● Granby

COLORADO

NEW MEXICO

HEATHER EHLE
**GRANBY
COLORADO**

PEACE MEANS BEING STILL and listening. It's hope. It's a calming, sacred place where good things happen. We try to do that at Project Sanctuary. We bring families up here and we create the quiet. We create an opportunity for families to experience peace, reconnect with who they are and where they need to go, and find a little bit of hope.

To imagine a warrior veteran sitting still and reconnecting with himself and his family sometimes could be a bit of a misnomer. They should soldier up. They should get through their problems. They should suck it up. They shouldn't have to ask for help. A lot of military families put that pressure on themselves. Here they can come to a therapeutic retreat with their family, and get the tools they need to move forward and be a productive member of society.

It takes a couple of days to build trust. The first two days, they've got big wide eyes. They're looking for the purple Kool-Aid. They're looking for the timeshare. What's going on? How could this be free? By day three or four—we call it magic—there's a shift.

Their shoulders relax and you start seeing some handholding. You start watching fathers with their kids. By the end of the retreat, at day six, they're totally different. There's a peace about them. They're happy. They're hopeful.

We joke that if the retreats were seven days, they would never leave. They form friendships and bonds with other families that have been here. It is an amazing transformation to watch.

I believe that everybody innately knows what they need in order to be happy and successful, but we don't always stop to listen to ourselves or that higher power or whatever you want to call it. When you're able to be still, then you know. So many times, the veterans come home, and they're asked, "What are you going to do now? Are you going to school? What's your job?"

They're missing a key step which is, who is that veteran? What is he like? What does he enjoy? Is he a dad? Is he a fisherman? Is he a hiker? What makes him happy? Where is his family? How do they play into it? If you're so focused on what you do that you forget who you are, then that could be a problem.

In military life, they're told what to do, when to go, where to live. Everything is mapped out for them, so they are battle ready. They know what they need to do within that scope. As they transition out of the military, they don't have that structure or those rules.

We had a combat veteran who was really struggling at the retreat. He was going through our healthy marriage classes. You could see the internal struggle. Our counselor pulled him aside and said, "What is going on?" He said, "I am battle ready. I knew I would die for my country. I knew who was on my right, who was on my left, who had my back. I knew what to do. I come home, and I'm not there. At work, I was not a quitter. I would never ever, ever quit."

The counselor looked at him, and said, "How many times have you been divorced?" He said, "Oh God, I've been divorced three times. I am a quitter." He said, "Is there a way to take me from battle ready to family ready? Can we do that?"

It's all about training. It's all about giving him that direction and that help.

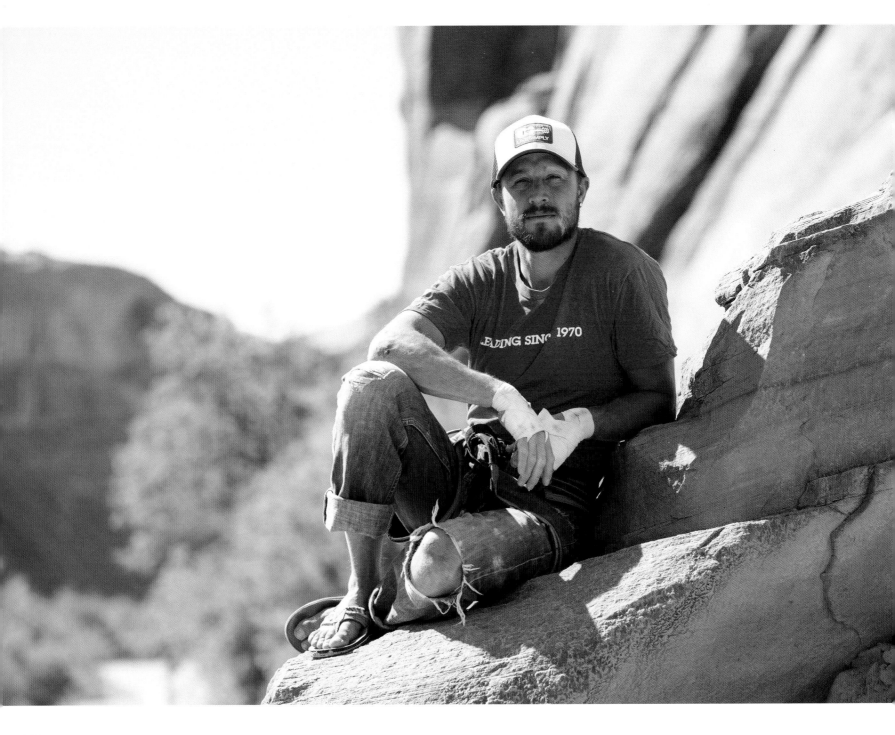

Taylor Bond lived the life that he thought was expected of him. He worked as an electrician for 10 years before, he says, he "freaked out," sold all of his possessions, and bought an RV. Now he lives in Moab, Utah, works for just over minimum wage at a local climbing shop, and climbs rock towers in the desert.

Y OU KNOW WHAT I LOVE about climbing? The idea that you can get your mind off of everything. It's one foot, one hand, and all you got to worry about is the next move. You forget about life in general, because you have to focus hard on what you're doing.

When I'm stressed out, or work's going wrong, or I'm having trouble with my girlfriend and everything is overwhelming, I get on the rock. When you're focused on putting your foot in the right position, or putting your protective gear in the right spot, it all just melts away. It's euphoric. You forget about everything and just focus on the goal at hand. You have to, because if you don't, you fall.

There are so many different ways to describe peace. Is it just the fact of no violence in the world? For me, being peaceful is being generous to people, and being as good a human being as you possibly can be. I try to stay around quality people, so all the climbing people that I'm around are good people. In turn, that makes me happy.

It's a beautiful thought to say, "OK, yeah, we're all just gonna get along." If you really sit back and think about it, there's always going to be that one [person] out there that doesn't want to go along with everybody else. You see it in everything. There's always one kid at school that's going to be a bully, one country that thinks it's better than yours.

I try to keep myself here in this little world, because the stuff in the bigger world just doesn't seem to get any better. I can focus on this and control what's around me. If you spend your whole life worrying, it's going to make life more stressful. Maybe one problem with the world is that people are not focusing on making themselves better. You've got to start on the inside and work your way out.

Life is difficult. It can be hard to move through sometimes.

I worked my ass off for ten years as an electrician, living how everybody expected me to live. Then two years ago, I kind of lost my shit because I had lived in the same town for 30 years. I sold my house, bought an RV, and went on the road. I ended up in New Mexico living with my friend. His family is Quaker.

I realized that Quakers are super generous to people, or at least these Quakers are. I came to Moab and started hanging out with my climbing partners, and they're the same way. It's become an important thing to me to be as giving as I can.

Just keep moving forward. I've been an asshole, and I've done lots of bad things, but not lately. It's easy to be an asshole sometimes, but just try not to do that.

You always have to hope that the world will change. I'm saying that it's unlikely. I would hope that someday, maybe not in my generation or the generation after me, they'll finally get it. Life can be so much better if there's not all this fighting and worrying about other people, and all that bullshit just stops.

IDAHO WYO.

NEV. UTAH CO.
 Moab ●

ARIZONA N.M.

TAYLOR BOND
MOAB
UTAH

"Everybody wants what they can't have. The grass isn't always greener."

"I always say that being wealthy is having a hogan with a dirt floor. No running water, no electricity. That's being wealthy because you're as close to mother earth as you can be."

Sheila Goldtooth

teaches Navajo culture and philosophy at Dine College in Chinle, Arizona. She also works as a traditional healer for the Navajo Nation. Her interest in healing began at a very young age when she saw her uncle do the work. She apprenticed with him and now performs ceremonies and blessings for people to help bring them back into balance and harmony, particularly for young people who struggle to balance the pressures and competing demands of western and Navajo societies.

THE PHILOSOPHY and the teachings were all a part of growing up. Learning the ceremonies made a lot of sense to me and I understood it at a very young age.

We learn in our culture that everything is alive and sacred to us, whether it be the rock, soil, air, wind, animals, insects, reptiles, and so forth. Everything has a purpose for living on this earth and we have mutual respect for everything that exists.

Being in peace basically means being in harmony with everything that is out there, with everything that exists in Mother Earth and Father Sky.

When you become a traditional practitioner, you don't have enemies. Your enemies become your friends. It's an understanding of having harmony with everything and everybody. Those that do harm to you or that don't like you, you're still going to be at peace with them. In our way, we don't practice anything harmful, we just pray for everybody and everything.

Western education teaches you to do things for yourself. You're going to be aggressive and you're going to try to be successful. In our culture, yes, you're responsible for yourself, but you have to remember the people. You have to remember Mother Earth. You have to remember where you come from. It's not going to be just an individual thing.

We had a system of peacemaking. Well, let's translate it as peacemaking. People would talk about conflicts, kind of like a conflict resolution session. If people were in conflict, local practitioners or prominent people in the community would come and talk about whatever the situation was and how it was affecting the community. That is still an option that people have within our Navajo Nation court system.

I work with mothers and fathers and grandparents that are struggling with youth. Sometimes we don't give the person time to explain the situation. As a practitioner who works with youth, I've seen that they just need somebody to listen to them and not prejudge them or make assumptions. A lot of times, before the child could finish a sentence, Mom jumps in or Dad jumps in, and cuts the child off. They don't allow the child to have their say.

The children feel like they're not respected. That's when all these other things start to happen. They will start to get defiant. They will feel that they're not important, not loved. They don't feel like they're a part of whatever is going on. They don't have the opportunity to really express themselves and be able to say what they want to say. That's where they start to rebel.

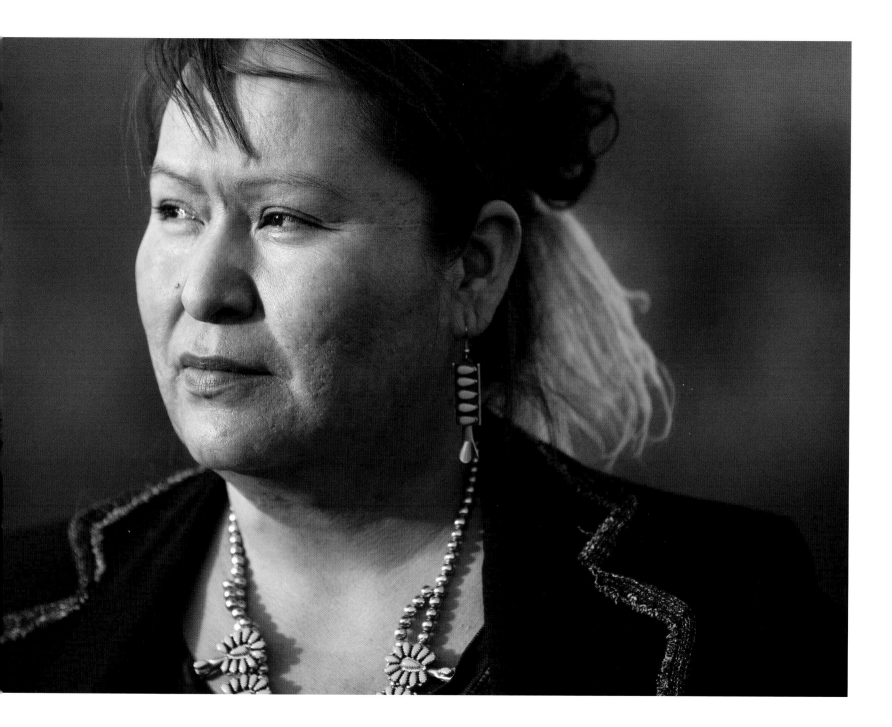

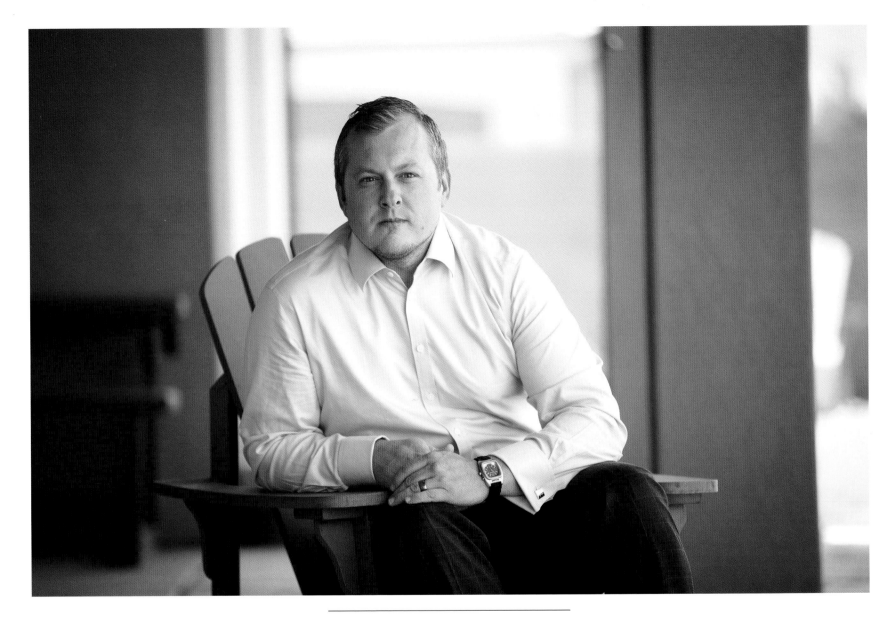

*"It's important to tell these stories
because it could inspire others
to do similar things."*

Brett Menzie had a history of kidney trouble in his family. His grandmother was on dialysis. His middle son suffered in utero from a kidney malfunction known as hydronephrosis, which required surgery when he was born.

While Brett was not a medical match for either of his family members, he recognized he only needed one of his two healthy kidneys. He joined a national donor registry and gave one of his kidneys to a total stranger just before Christmas 2007.

I LIKE TO HELP OTHERS or volunteer where I can. When I was little, my mom was leader of a women's group within the church and she would always find ways to help the women. I would tag along with her and help her out.

I remember, in particular, a woman who had cancer. We would take her to chemotherapy and pick her up. My mother was an example of service, so today, I volunteer for a hospice organization where I interview individuals that are in their end stages of life. I get their life story as best as they're able to tell it, and I provide an audio recording to the family.

I try to get at the essence of who they are. It's interesting to hear some of their memories about family. Those are the stories they want to tell. It's an opportunity for them to give one last gift to their family and to create a legacy. I'd like to do that someday for my own children.

When I donated my kidney, my mom called up a news station and had them come interview me. I didn't want it, but she still sent them. I'm like, "I don't want to use my name. I'm not trying to seek any sort of praise." It was just a matter of helping somebody. So they used just my first name on the news.

There's over 120,000 people waiting for an organ donation in the United States. Twenty people on that list die every day, but it's still growing because even more people are added to it.

It's amazing what human beings are able to do when we get together and put a plan into action. We create something that is life changing and life saving. Much like a branch that's able to sprout several leaves and twigs, we're able to improve society by just impacting one person who, in turn, impacts someone else, and it continues on and on.

Find one way every day you can improve the life of somebody around you. If you're single and have a roommate, maybe you want to shine their work shoes. If you're married and have children, you write your child a note that says, "I love you. These are the reasons why." Or you write a note for your spouse. Do something nice for somebody once a day, every single day. That is the best wisdom I can impart.

IDAHO WYO.

NEV. UTAH CO.

● St. George

ARIZONA N.M.

BRETT MENZIE
**ST. GEORGE
UTAH**

"There's something beautiful in you and beautiful in me. We mess up and we're stupid, but there's beauty in reconciliation that can't really be explained."

Jarell Wilson describes himself as black, gay, and Christian. He lives in the South and, at times, he struggles to balance his three identities in a society that he says doesn't embrace two thirds of them. He believes that people often try to put identities into boxes, and that results in stereotypes that lead to stress and conflict. Yet, at the end of the day, Jarell finds beauty and peace all around him. He finds joy in each of his identities.

THE PROBLEM WITH STEREOTYPES is that people don't always work out that way. Saying all black people are violent and aggressive cuts you off from meeting nice friendly black people. Saying all Mexican Americans are undocumented workers is a lie. But stereotypes have become like scripture in the American psyche. It's dangerous. And for people who have to balance different identities—such as black, gay, and Christian—it's stressful because you don't want to be stereotypical this or stereotypical that. You want to be you. I just want to be Jarell.

I get overwhelmed trying to carry all of this but, as a Christian, I have to find joy in it. There is so much beauty in all of my identities. I love the gay community. I don't think there is another community in the world that is more accepting or more loving. If I run into a gay person in Africa, it's like running into a long-lost cousin. And the same thing with Christians. If someone sees that I'm wearing the Methodist cross and flame, they will stop and say, "You're Methodist? What church do you go to? Maybe we know somebody." I love knowing that no matter where I am, I am at home. It's the same thing with being black.

Peace comes from knowing who you are. It comes from knowing that no matter what you look like, you're beautiful. It comes from knowing that the same beauty you have, all of humanity has. We have to wake up every day and decide to find the beauty that is within us. I try to stay joyful by remembering that I have a home, that I'm loved, and that for some reason, God wants me to be this way.

In South Africa, right after apartheid, Nelson Mandela was elected president and the people that had been in the majority, the Boers, were afraid. They said: "Oh no, the black people are in the majority, they have control of the Army, and they are going to kill us. They're going to want revenge." Nelson Mandela gets this crazy idea: Let's share our stories and that will bring peace. So there's a giant tribunal. And people bring forward their stories and present them to the people who have done them wrong.

A mother talks to the soldier who shot her son. A woman tells the military: "You raped me because I was a black woman and could not defend myself." They ended each and every session with "I forgive you." For me, that is justice: bringing forward your complaint, airing your grievance, and having the other side hear and see how they harmed you.

People repenting in their hearts for what they've done, reconciling, and walking out together, holding hands, hugging each other because they realize we're all made in the image of God. There's something beautiful in you and something beautiful in me. There's beauty in reconciliation.

The trick to peace is remembering that everything is sacred. Everything is holy. For people who are not religious, I'll say this: Everything is filled with the very essence of awesomeness.

If I recall correctly, in the Bible, just a few chapters after gay people are condemned and thrown to death, God tells Moses to bless the children of Israel: "The Lord bless you and keep you. The Lord make His face shine upon you, may He be gracious unto you. Lord, lift up His countenance upon you and grant you peace."

That's his commandment: *The Lord grant you peace*. I find it interesting that God's signature is *peace*. *Shalom*. It's hello. It's goodbye. It's peace when you come, peace when you go. That's the way God wanted to be known. Humanity could learn from that. We should be granting each other peace.

JARELL WILSON
**ROUND ROCK
TEXAS**

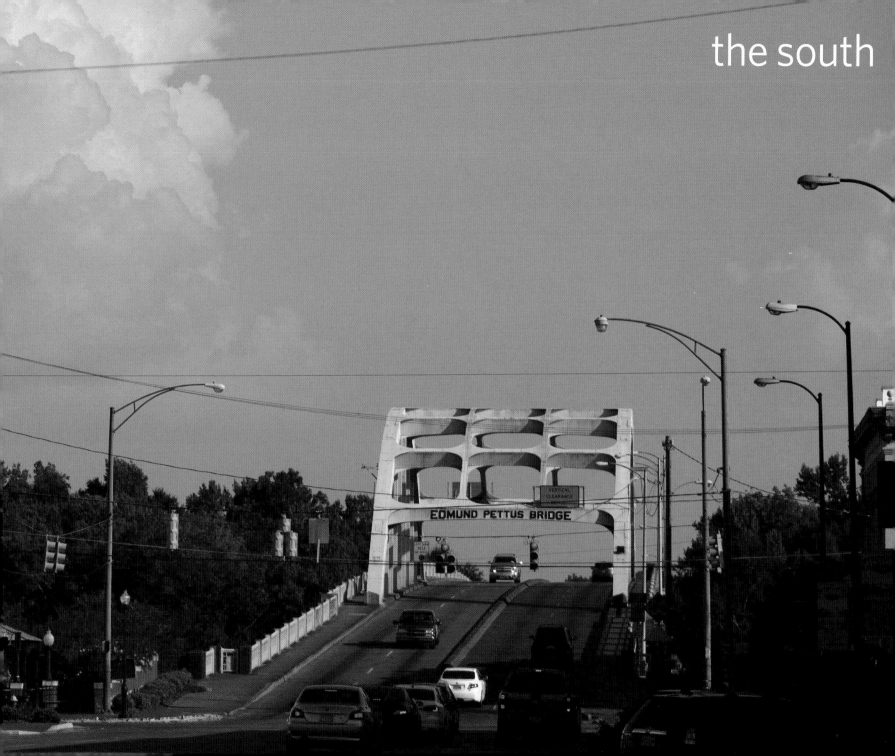

the south

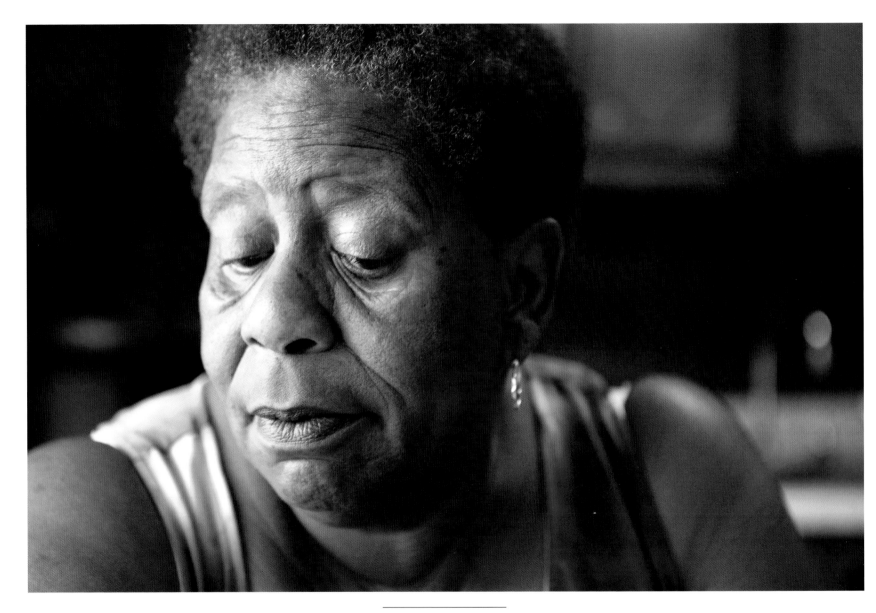

"My niche in life
is teaching the lessons of the past
to facilitate a better future."

Joanne Bland

Joanne Bland was 11 years old when she marched across the Edmund Pettus Bridge with Dr. Martin Luther King Jr. Heading from Selma toward Montgomery, the activists were committed to securing voting rights for all Americans, but on March 7, 1965, they were violently attacked by law enforcement officers. It became known as Bloody Sunday.

I interviewed Joanne at her home in Selma in August 2015, just 12 days after Michael Brown was shot and killed in Ferguson, Missouri, and the city was gripped by protests. She spoke of the pain of watching televised scenes from Ferguson that reminded her of scenes she witnessed in Selma 50 years ago.

A S A NATION we've come a long way, but we have a long way to go. As we elders get weary, the children are going to have to take us where we need to go.

People don't talk honestly about race. Just don't talk about it, and we'll all get along. And the moment I question something that I think is racist, you put up a wall and we can't talk because you feel like I'm accusing you.

Here in Selma, in 2000 we elected our first African American mayor in a town that's always been at least 65 percent black. That same year, a statue of the founder of the Ku Klux Klan was erected on the grounds of one of our museums. It really upset me. It said, "You may have a Negro mayor, but we're still here."

Protests shut Selma down. And this little old [white] lady told me, "Y'all better let us have something."

Do you really feel like we're taking something away from you? Because to me, her fear was that if we were empowered, we would treat them the same way they had treated us.

When you continually get hurt by people who don't look like you, you are suspicious of them. Here you come smiling, but you are a wolf in sheep's clothing. You're white and eventually you're going to show your true colors—that you don't like me. Period.

I tried to teach my child and my grandchildren that it's not like that. We try to take people at face value. But it's hard for me to explain how you expect racism when you're black. You expect discrimination when you're black. And we don't question it as often as we should.

If I was a child, we could have a fist fight this morning and be playing by noon. You know, we're still buddy-buddy. But adults hold onto craziness. We hold onto stupidity. You have a wall that you throw up. I have a wall that I throw up. That wasn't there when we were kids. We shared what children share: a sense of peace and freedom, to play, to love, to just be happy.

What happens to us when we grow up is life. And sometimes it makes us better, but more often than not, it makes us worse.

One day we'll be all right. I'm just tired of waiting for one day. I want it to be now. I want it to be in my lifetime. When we were growing up in the 1960s, I thought by now we'd have that Beloved Community and everything would be peaceful. It has not happened.

JOANNE BLAND
**SELMA
ALABAMA**

FIONA ORR
FAYETTEVILLE ARKANSAS

"I'm not always able to put food into a homeless person's hand or sit on a corner and protest with signs, but sometimes being able to put that idea of peace and justice into somebody's mind feels like it makes a difference."

Fiona Orr, fifteen-years-old, is home schooled in Fayetteville, Arkansas, where she volunteers regularly at the Omni Center for Peace, Justice, and Ecology.

She draws and paints. From a very young age, she liked to put beautiful things on paper so that other people could see the same beauty she did.

Fiona is discouraged when adults don't recognize the potential in youth, but she has found many adults who have served as her mentors. She values that exchange of ideas across generations.

The world's problems can seem overwhelming to a teenager, Fiona says, but surrounding herself with people who work toward the common good every day helps her understand that change is possible.

AT THE OMNI CENTER, I'm exposed to the idea of peace and what it should look like. Just having people talk to me about community activism and human rights has given me an idea of what I want peace to be.

Keep talking about peace: what it should look like and how you get it. Talk about it with your friends or your family. Think about it. It's just such an important part of fixing and changing things in this world.

Teenagers sometimes aren't paying attention, but it's because we often don't get paid attention to. I know I wouldn't pay attention to somebody who's not paying attention to me. That sounds very basic and stubborn, and you may not even realize you're doing it. If an adult is not listening to my ideas because I'm young, then I'll think, "Oh, you're old. I'm not going to listen to your ideas." It happens both ways.

In this community, we have people who guide you and take you seriously. We're not constantly being told that we're irrational teenagers. When you see adults that are successful, it becomes a lot more realistic to achieve [your goals].

I want to be an animator and make movies about the environment and that seems like a really big thing to do. Some people say, "Artists don't make much money," but then you have other people who say, "It's really important to be able to do something that makes you happy."

The adults in my life help make my goal seem more realistic. That helps a lot. Adults are important to youth in so many ways.

I'm very involved mentally in what's happening in the world. I think about it, I research it, but then late at night, when I'm trying to go to sleep, it'll all come back. The problems in the world seem very big, and I don't feel like I'm able to make any difference. It's an overwhelming feeling and sometimes you just want to break down and cry. You think, "I'm just one very small teenager." But it's not like I can ignore it. I just become very sad sometimes.

I try to focus on becoming well spoken and talking to people. If you can change the opinion of one person or get one person involved, then that other person can get five people involved, and those five people branch off. You have to break it down really small. Just think, "I can only start with me and the person that's in front of me now." If you think about it on that scale, then it becomes so much more realistic to be able to help and change things.

Yes, I'm one very small person but with education and free-thinking, you can always make a difference. It becomes a lot more reachable.

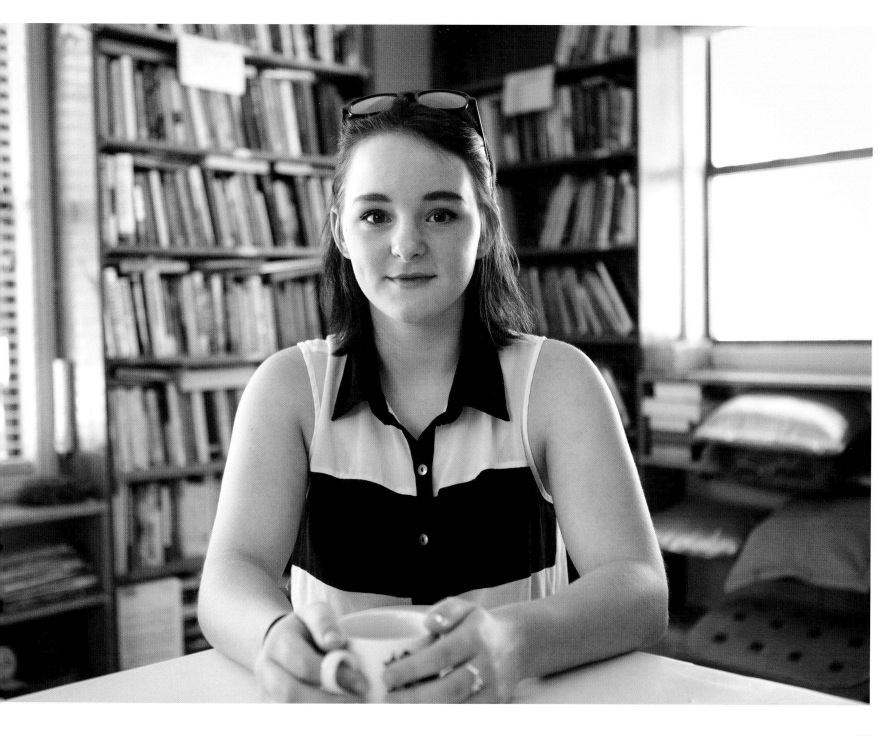

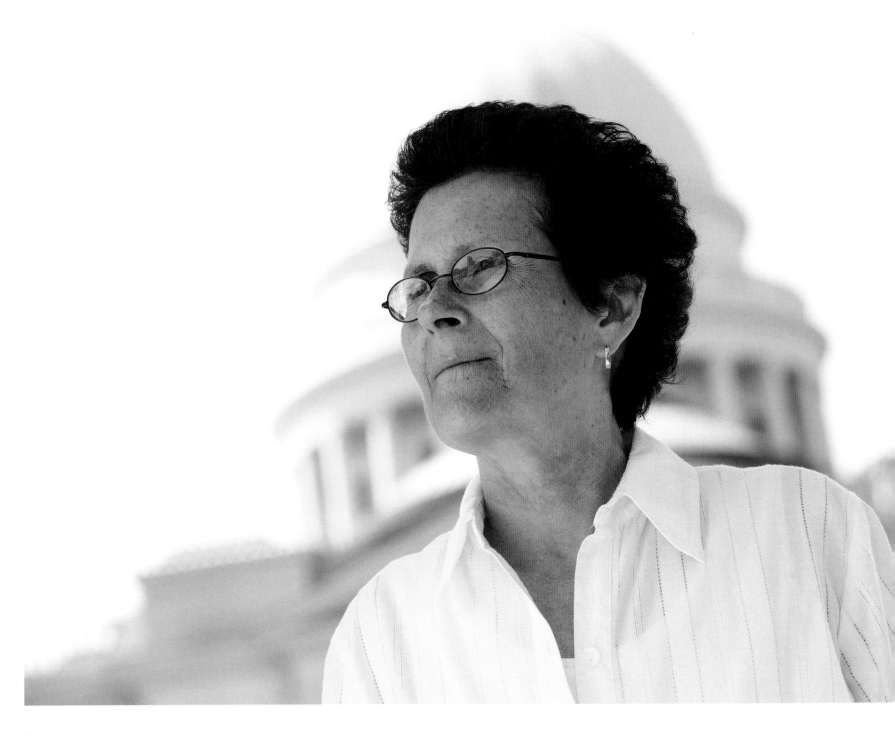

Kathy Webb served six years as a state representative in the Arkansas legislature and now is executive director of the Arkansas Hunger Relief Alliance. An activist all her life, Kathy talks about the shift from working with like-minded activists to the process of compromise she encountered as a legislator.

I HAVE ALWAYS BELIEVED that you can make a difference. I have been an activist all my life.

My mom had this little plaque on her bathroom wall and it said, "What you are is God's gift to you. What you become is your gift to God."

There are a lot of people, particularly in the South, who would challenge some of my spiritual or faith beliefs because I am a lesbian. I was the first openly gay person elected to office in Arkansas. At this point in my life, I am pretty comfortable with most everything about myself. Always trying to get better, but I am comfortable in my own skin.

When I went into the legislature, a lot of people were not used to being around gay people and I could tell they were uncomfortable. Folks said, "The only thing you probably care about is the gay agenda." I am not quite sure yet what that is.

I am passionate about the environment. I am passionate about equality. I am passionate about economic opportunity for everybody.

If you show people who you are and that you care about the same things they care about, most of the time you can bring people around.

There were people, of course, who told me I was going to hell. For the most part, that was the exception rather than the rule.

When you say the word peace, I think of the necessity of people to listen to each other. When you contemplate a subject, try to remove the lens through which you look at the world and look at the problem or the issue in a new way.

That is one difference between being an activist and being a legislator. As an activist, I didn't have to deal with people that I disagreed with. You do your work, you meet with legislators if you want a certain bill passed, but for the most part, you go have coffee or drinks afterward with people you agree with.

As a legislator, you have to deal with all kinds of people and, if you want to be effective, you have to realize that good people can have different ideas. You may be voting against a bill one day or someone may be voting against a bill that you brought up, but you need their vote the next day on something else. I try not to judge others the way people have judged me. I try to be open to working with all kinds of people.

To put our political process back on the rails, we need people who are willing to have a dialog with a person who believes differently than they do. We need people who are willing to set an example, willing to disagree in a positive way rather than resort to name-calling.

You have to show the public that you mean what you say. You do that by your actions. You show people that, hey, I hang out with this person who is very different from the way I am. We don't agree on things, but we can have a civil conversation and we can find something that we agree on.

MISSOURI

OKLA. ARKANSAS

Little Rock

MISS.

TEX.

LA.

KATHY WEBB
**LITTLE ROCK
ARKANSAS**

*"We are all
a whole package,
with the pluses
and the minuses."*

CARL KENNY
DURHAM
NORTH CAROLINA

"The truth is the only thing we can really control is our own activity. If there's hope in me, having hope in the world, then that's all I need."

Carl Kenney is a minister, author, advocate, teacher, and in his own words, a "prophet of the people." He believes that we spend too much time and energy fighting one another because of our differences—with devastating and wide-reaching results.

W E'RE LIVING IN A WORLD of broken people. Many people don't even know they're broken. We spend so much time and energy fighting each other, be it based on race or gender, political differences, or religious differences. I try to be the person who stands in the middle and helps others hear each other. People can't hear because they're so glued to their ideas. I'm telling people to shut up long enough to listen to each other.

My theology is rooted in the compassion of the Christ. I'm a person who has experienced the love of God after having made my share of mistakes. I've been in recovery over 30 years. My sister died at age 13. I was a teenager and I started using substances to hide my pain. My God loved me through that and I bring my own personal experience of recovery to my faith. I see that I am worthy of God's love and I see the very spirit of God in every face. I cannot look at a person and hold myself higher than them. I can't measure them as less than me because of what they believe, or their orientation, or any other issue that may be present in their life.

My theology is an experiential theology. It's been supported by the teachings of Christ who found me and said "I love you still," knowing that I did not deserve that. It comes out of knowing that even in my walk of faith, I've made my share of mistakes. I have not been a perfect vessel. I never will be, but I've been faithful and I see that in everyone I meet. We share in common our frailty. Who am I to judge? That's what gives me the strength to keep on moving.

When you say peace, I get an image that haunts me in my sleep. I see a world void of hostility. If we are created to love, and I believe that we are, than loving each other should be the easiest thing we have to do. I just want to yell, "Be OK with each other!" I think of the kingdom of God as a world where people are able to coexist without hostility, without judgment, without ridicule, without measures. I don't have to tear you down for the sake of making me better.

When I look at myself in the mirror, I say, "I am who I'm created to be," and I don't have to add to that. I don't have to add more money or more prestige or anything that others value as significant in this world. I am at peace with myself because this is what I'm created to be.

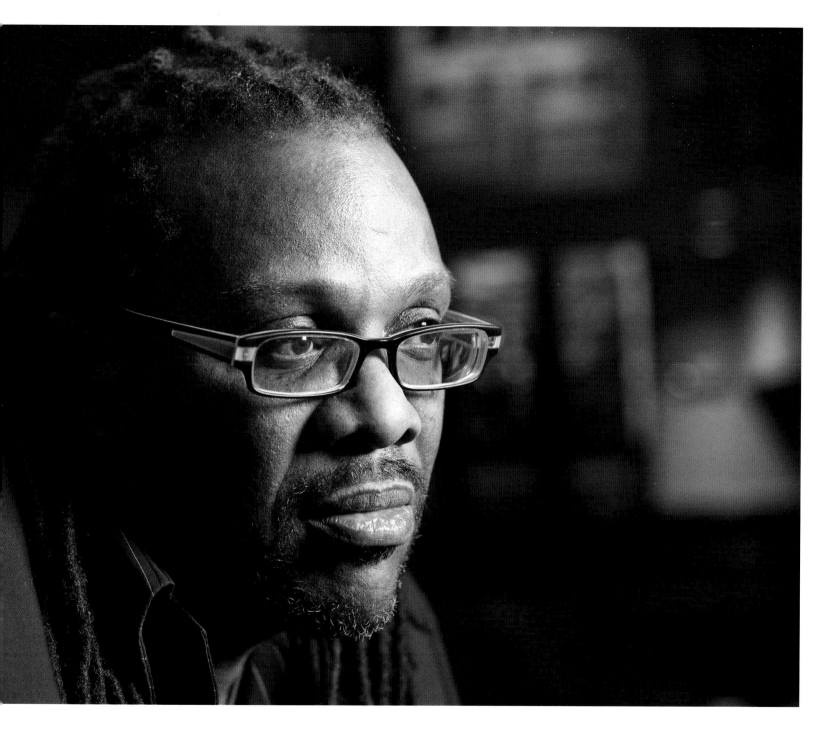

"If there are no rules, the bully wins."

Donna Watts is president and chief executive officer of the South Baldwin County Chamber of Commerce in Foley, Alabama. She has worked in business development for 30 years and takes great pride in helping people pursue the American Dream.

Donna talks about the triple punch of hurricanes, recession, and the BP oil spill, which have brought people in the region to their knees. She talks about the sense of community that develops through hardship and that brings people together to help themselves and one another after disasters.

We have become accustomed to natural disasters, Donna says, but she talks about the oil spill with a different kind of frustration. A strong proponent of business, she shares her anger with the federal government for allowing one corporation to rob so many people of their businesses, property, and way of life.

I REMEMBER IT like it was yesterday, when the well exploded and 11 people lost their lives. That was tragic. Those were dads and husbands and sons.

We all said, "It's not going to get to us." But the oil did get here and it was devastating. I got in the car and went to the beach. I had to see it. I just stood there and cried. It was heartbreaking. I told my husband, "I feel responsible for the Gulf of Mexico." I've got to help clean up the Gulf of Mexico because I'm a fixer. If you've got a problem, I'm going to do my best to fix it for you. I take responsibility for my community.

I remember distinctly the moment when I said, Donna, our way of life is gone and it won't return. Everything people had worked for up to that point was gone. Not just their house and their boat and their stuff, but life as they knew it.

My first reaction was to be mad. I hold our federal government responsible for the fact that [the oil company] wasn't ready to file claims or to clean up. If the government allows a company, no matter who they are, to go off our shore, there should be strict requirements of that company to be responsible and to take aggressive action should something go wrong.

We're just now beginning to get rid of all the repossessions and short sales. People profited from that disaster, and that's not right. It is the way the world works and I acknowledge that, but it feels like somebody won that didn't deserve to win.

It feels grossly unfair. Maybe it's the difference between dealing with a God-made disaster and a manmade disaster, because you want the people who made the disaster to pay. How could you not be prepared for the worst to happen? That's unconscionable to me. Look what you've taken from these people.

I'm just one person and I don't have a loud voice in this world, but I'm a hardworking, taxpaying, law-abiding citizen in the United States of America. I am terribly disappointed that my government would allow our way of life to be ruined forever. We don't get to go back. We can't allow this kind of thing to happen. You have to fix it because if there are no rules, the bully wins. And that's not what this country was founded on. Rules and laws have to apply to everybody and be fair across the board, because you can't subject people to this.

I'm willing to compromise. I'm willing to give a little to get a little. But there's not enough people in decision-making positions who understand what it's like to be robbed of what you've known all your life. They're not touched by it and so they have no empathy. This may never happen to you in your lily-white neighborhood or reach you on your pedestal of wealth and power, but what about those of us who don't have that privilege? We have a responsibility to protect all citizens in this country. It's our moral obligation to protect those who can't protect themselves and who don't have a voice. If we don't, who will? If I don't, who will?

TONY THOMAS
CLINTON
TENNESSEE

*"When something
touches my life
some way
or has an impact,
I usually write
a song about it."*

Tony Thomas was born and raised in the Cumberland Mountains of eastern Tennessee. He worked in the coal mines and never finished high school. Tony records folk musicians in rural areas in an effort to preserve the local culture. He is also a singer and a songwriter. Tony says he has written more than 200 songs and when he dies, they are all going to be popular.

Tony talks about growing up surrounded by models of caring. One of his earliest memories is of his grandmother rescuing a cardinal from a bitterly cold night, bringing it inside their cabin, and wrapping it in a quilt until it had warmed enough to fly again.

I GREW UP WITHOUT ELECTRICITY and plumbing in the house. It was a hard life. I grew up in a time when neighbors were there for each other. You could leave your house unlocked and didn't have to worry about anybody breaking in.

I'm big on helping out with charity, especially when it comes to the elderly and children. I'm big into my church work at Mount Harmony Baptist Church. I like to help my fellow man in every way I can—through my music or whatever I can do to make life better for them. That's what peace means to me. I feel like when I'm doing things for humanity, my father above smiles down on me for that. I feel like that's why I was put here.

Many times I've seen people that were poor as church mice, yet they would take part of what they had to help others. My father was that way, and my grandmother. I guess witnessing the way they were firsthand caught on with me, because I could see the goodness and the love. It's not something you gotta do, it's something you want to do. It's in you to do it. You feel full. It's the best feeling in the world. It's a natural, spiritual high when you know you've done something to help somebody. It's what some of the old-time church folks call being richly blessed.

People from other parts of the country that have never been here would find people from Appalachia to be quite different. They might refer to them as backwoodsy or hillbillies, but if they ever got to know us, they would see us in a different light.

It's the most wonderful place on God's green earth, as far as the beauty of it and the beauty of the people. If they ever tried us, they would love us. Good people here in these mountains is what I'm trying to say.

Some of our people that live in the mountains are hard to know, but it's the love and the kindness that they show when it comes down to it that really matters. I've lived other places and I can get along anywhere, but there's something special about the people here in Appalachia. I think all parts of the world has a little Appalachia in it, if you go to thinking about it. There's always people with a lot more good than bad when it boils down to it.

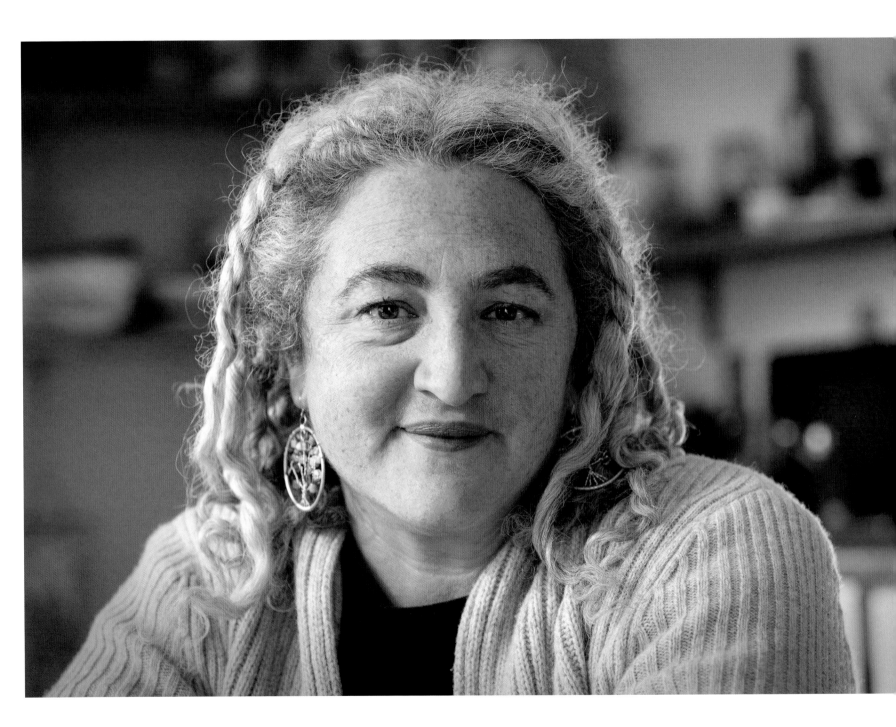

Claudia Horwitz is founding director of Stone Circles at the Stone House, a 70-acre retreat center outside Mebane, North Carolina, dedicated to the support of people and organizations working toward social change. Claudia's efforts grew out of an awareness that social justice work could exact a tremendous toll on people, and her desire to make the work of building social movements more sustainable.

CLAUDIA HORWITZ

**MEBANE
NORTH CAROLINA**

"There are ancestral, cultural, and political legacies that survive and thrive because they're not interrupted with some kind of searing reflective lens."

FOR ME, the only valuable relationship to peace is the complex one. What is the intrinsic relationship between how we balance an internal sense of peace with global possibilities around peace in the most unlikely places: actual spaces of conflict, war, violence, oppression, and poverty? It's that kind of inextricable link that embodies for me why it's even worthwhile to talk about peace.

There are words we use so often that they lose their meaning. I think *peace* is in danger of being one of them. Folks focus on one meaning of *peace* and forget or ignore or avoid the word's other layers of meaning. I've seen a lot of people head down a spiritual path. They're searching for some kind of inner peace, whether they talk about it that way or not, yet they don't recognize the larger societal forces at play that are intimately related to their own search and the collective search for inner peace. Conversely, the opposite is true. It's heartbreaking to hear people talk about peace on a global scale without any real shred of recognition of what that would entail internally.

I am most interested in the messy places where all these different understandings of peace begin to intersect. How is it that people are fortifying some kind of inner fire or inner calm? How do they find the ability to be fully present to what is unfolding in the moment? This is what I think brings the greatest peace. I'm speaking as someone who has been largely on a Buddhist path. That willingness to sit with reality as it's unfolding over time is, for me, the source of internal peace. But how do we bring that into the mix with a commitment to collective liberation? Where does peace fit into that?

I'm pretty sure peace is a process. It's a sort of balance, and nothing is ever in balance for very long. The very essence of balance is that we're almost always out of balance and moving back into it, whether it's a human searching for balance or an object, I think peace is just as easily defined by the process of moving away and back as it is in its static state, because the static state is so fleeting.

Sometimes I worry that our most powerful and important ideas become words that are used to paper over a deeper level of exploration and analysis. I have that fear with the word peace. We need to be rigorous in our understanding of peace and we need to be specific. We need to identify the kinds of peace we're talking about and we need to be unflinching in our ability to articulate that and put it on the table.

I feel like folks are talking about it less and less in these ways that I find really fascinating and that's alarming to me. I wonder if we've given up on the possibility of peace and we're settling for whatever else is possible—occupation, a low level of conflict, making ourselves comfortable with proportional response—whatever the thing is in terms of the global arena. Have we given in to the darker side of our nature in some unconscious way that we're not totally aware of? Have we been complicit? Do we really want to do that?

I'm not a pessimist, but I do see patterns and I've seen this pattern over time: We have been less willing to put the best possible scenario in the center and to aim for that. I think we've started to settle.

ELAINE BAKER

**MOUND BAYOU
MISSISSIPPI**

Elaine Baker grew up in Mound Bayou, Mississippi, also known as "The Jewel of the Delta." Founded in 1887 by former slaves, Mound Bayou is the oldest self-governing all-black municipality in the United States. Elaine grew up in an era of segregation, with "white only" and "black only" signs in neighboring communities, though she didn't experience day-to-day racism in Mound Bayou. She learned that her value and worth were not determined by others. As a young girl, she picked cotton for 2.5 cents a pound and went on to get a PhD in sociology from the University of Georgia.

MOUND BAYOU has historically produced individuals who have gone far beyond the confines of Mississippi and even the United States to make their mark. The legacy of achievement remains very much a part of who I am and the circle of people that I grew up with.

It's a legacy of education, spirituality, religion, economic development, and self-pride. It's not a perfect city because we're human beings here. There seemed to be, during the first 15 years of my life, a sense of gratitude for the legacy of our founders and the early settlers. There remains a nucleus of people who want to maintain that peace of mind, if you will, of community, entrepreneurship and self-help.

How does one maintain one's self when part of the world is telling you you're not worth it? You do that because of the environment that does not deny that reality, but helps you not to be defined by that reality. You learn to live in Mound Bayou as free people and to craft your own future. We had role models. You were expected to be all that you could be.

When I think about peace, I think of tranquility and calmness, of having come to an understanding of who you are and what the world is, knowing there's a place inside of you that no one can take from you. Above and beyond, it is knowing that there is someone greater than you who looks down, who knows all, who is the great I Am, in spite of all of the other garbage that goes on.

I believe that there is a God who's a sovereign peace. If you can stay tapped into that force—it doesn't mean that negative things don't come—but if you hold on, you will eventually get through it, even as the ultimate end is death.

I have come to appreciate demonic forces—jealousy, envy, greed. Those forces foster enmity. For me, there are positive forces and there are negative forces. One has to develop a discerning spirit to be able to know when they are rising up in you and where they're coming from.

God has enough for everybody, but everybody doesn't get the same thing.

I think it's important that you revisit: What are your core values? What are your core principles that don't change? Love for one another, helping your neighbor out, pride in accomplishments and achievements.

The world does change, and I'm glad about a lot of those changes. I don't have to use a rub board to wash. I recently bought a washing machine and it has all this technology, but I think that my generation, particularly, became so mesmerized with technology that we threw away, we discarded, we rejected those core principles of family and spending time together, getting to know one another, and loving people unconditionally. We got lost in the mayhem of finance. Money is important, and we need to be good stewards of those resources, but we lost our sense of community, that the sum is greater than the parts. When I bring my strengths to your strengths and combine those with others, we have a much greater mosaic than if I just stand out there alone.

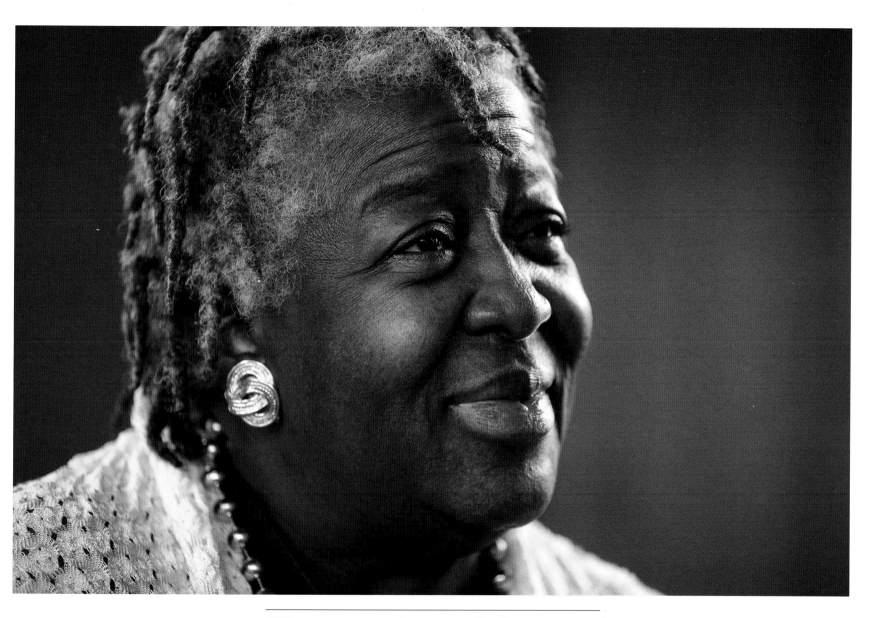

"You grew up with a sense of value in yourself that you weren't any better than anybody else but nobody else was any better than you."

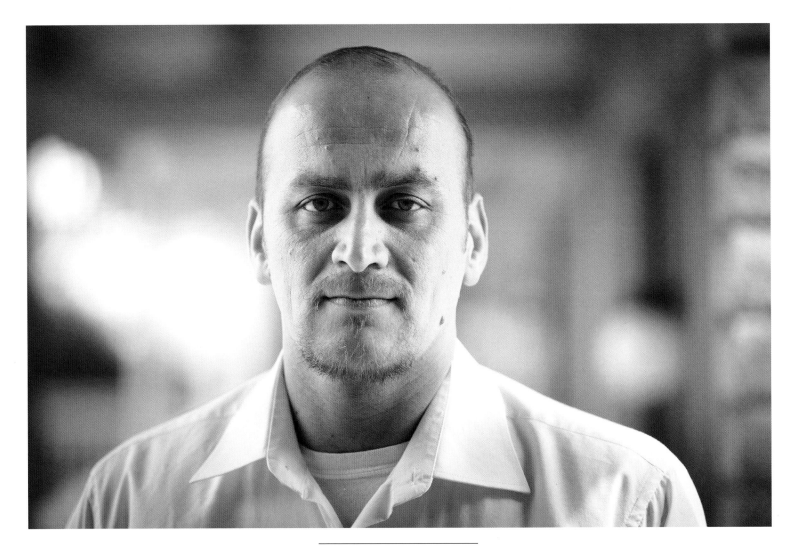

"*Only the good things
that you do with others
will be cherished
after you're gone.*"

Humam Taha graduated from the University of Mosul, where he studied to be a translator. After the United States invaded Iraq, Humam joined the coalition forces as a translator to help resolve cultural differences and misunderstandings. In 2007 he moved to Dallas after Congress passed a bill giving sanctuary to linguists who worked with coalition forces and their families.

Humam dreams of returning to Iraq but, like many others, he lost family members in the violence after the invasion. While he recognizes that life had many challenges under Saddam Hussein, he says that his life became less secure after Hussein was killed.

UNFORTUNATELY, the post-invasion era is not as safe as we thought it would be. You have numerous intelligence services, from God knows what countries, working on the ground in Iraq—though they are working in the country's interests—and you've got different political parties and components who are basically regulators. They fight over power, and the people who are not affiliated with these parties pay the cost. When the poor, day laborers go out in the morning to make a living for their families, they get blown up, or they get arrested, or they get harassed. They are paying the cost.

I think the most sought-after need now is for the people in Iraq to trust one another. I cannot trust my neighbor if he's affiliated with militant groups. I can't talk to him or her because they might take what I say to their leaders and I could get hurt. The sectarian differences appeared all of a sudden. There's no secret that there are differences, but these differences did not prevent people from other sects to marry each other, to coexist peacefully.

People from the north would go to weddings held by people in the south. Sunni and Shiites were cordial even.

The divisions that came about after the invasion have been annoying everybody in Iraq, and I think the people are just afraid of taking any action against them. These militias operate on the ground and it doesn't matter what background you're from. If you violate one of the rules, which you do not know about, you get killed or you get hurt.

I believe peace is being able to coexist with other people, no matter what their religious, ethnic, racial background is, without worrying about somebody hurting me physically or emotionally.

I believe selflessness is a great weapon for people who want to live in peace, because if I see you caring about me just like you care about your family and friends, I'll never hurt you. It's as simple as that. It doesn't matter where you're from, what religion you follow, if you care about me more than you care about yourself, I can't do anything but respect you for the rest of my life.

What connects us as human beings is the desire to be good and do good, and to show respect to one another. I don't understand why the most influential people in this world don't reflect on what happened to the most prosperous, ancient civilizations and empires that ruled the world before.

You'll leave what you have here, no matter what you do, no matter how much money you have, and no matter what kind of power you can master. It doesn't matter if you have the strongest army in the world or not, it doesn't matter if you have the most money in the world or not, the gold, the uranium, whatever material you think is worth the most, it doesn't matter. The good that you produce is what matters.

N. M.

OKLA.

Dallas ●

TEXAS

MEXICO

HUMAM TAHA

DALLAS
TEXAS

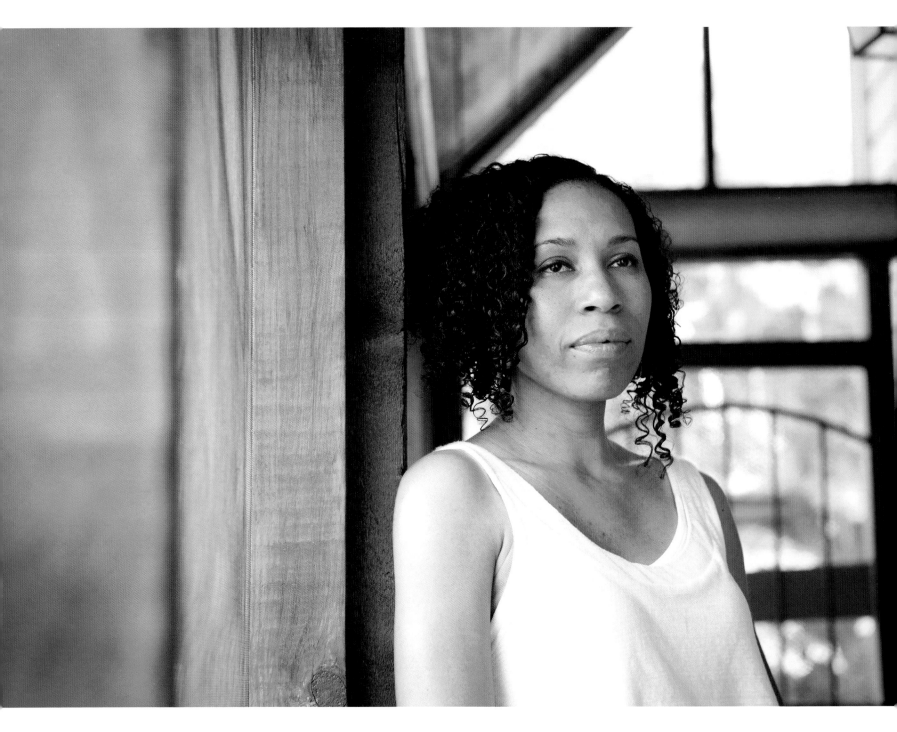

Shay Littlejohn

Shay Littlejohn was trained as a lawyer and worked at a firm in Washington, D.C., until she decided she wanted to be "free of schedules, free of being tied to a clock, of needing to have a hierarchy of titles and income."

Shay went back to school to pursue her love of music and now balances her time between practicing law and working as a country singer and songwriter in Nashville, Tennessee.

LIVING IN THE GREAT USA, you can be and do anything you want to be. I've always loved storytelling. My grandmother would tell me stories at night when I spent summers with her in Overland, Ohio, so the storytelling and all the imagery comes from that feeling of small town life and being in wide open spaces. I've always been attracted to that, and that's the kind of music I like. I love country music because it has heart, it has stories, and it has imagery that represent small town America.

It's true that sometimes you have to suck up things you don't like and be a grownup, but you also have to analyze your particular responsibilities. You don't want your children to starve, but if it's just you and you're willing to eat beans and rice, then maybe you choose beans and rice over steak in order to be happy.

When I was working the Washington lawyer lifestyle, I would spend lots of money on nice clothes and shoes, vacations, and eating out all the time with my single friends. I was making a lot of money, but I was also spending a lot of money. It finally dawned on me that I was spending a lot of money in order to buy the happiness I was not having on my 9:00 a.m. to 8:00 p.m. clock. It wasn't worth it.

Peace means contentment. It means not having to worry. It means being OK with wherever it is you are. I can't have peace without freedom. Freedom for me is waking up and not having anybody to answer to except myself.

My understanding of peace comes from the experience of making right and wrong decisions. I find that when I make right decisions, I have peace, and when I make wrong decisions, I have anxiety.

It's a mystery why we can't hold onto peace. I think it's partly caused by unreasonable expectations we have of ourselves. Perhaps people create more strife and anxiety than they need to. Realizing that we're not perfect and that other people aren't perfect would help a little bit.

Going back to school, I was afraid of what I didn't know. I didn't know if I'd be any good at music. I didn't know if it would be difficult. Getting off that lawyer track was a little disconcerting. I spent my whole career working my way up the ladder, only to say, "Well I'm going to climb back down and go to music school."

It's about finding the courage to change. It doesn't have to be a huge change, but there's certainly little things that can be done here and there to create more of an atmosphere of peace and satisfaction in a person's life.

Make sure that you are choosing the life that you want, because you only have one opportunity. If you find yourself in a place that you don't care for and you're wondering how you got there, it's probably because you were letting other people's expectations push you in a certain direction. It's important to be thoughtful about what we do and how we spend our time.

We have to find a way to turn off things that are negative. If you keep playing a negative story in your mind, if you keep telling yourself bad things about yourself, if you don't believe in yourself or in the person you're with, that will become what you believe and that will become what you accomplish. You'll make it happen. It's important to see the good that exists in people and in the world, and play that music a little louder than the negative stuff.

MO. KENTUCKY

● Nashville

TENNESSEE

MISS. GA.

ALA.

SHAY LITTLEJOHN

**NASHVILLE
TENNESSEE**

"One of the greatest gifts you can give to your children is to be able to say I did the things that I wanted to do and when it's time for life to come to an end, I don't have to regret all these dreams that went unfulfilled."

ARKANSAS

MISSISSIPPI

LOUISIANA

Chauvin ●

Gulf of Mexico

KENNETH THERIOT
**CHAUVIN
LOUISIANA**

"When we were shrimping, we all worked together. One would build a boat, we'd help him. The next one would build a boat, we'd help him and then pretty much everybody wound up with a boat at the end so it worked out pretty good."

Kenneth Theriot is a third-generation Cajun shrimper from Chauvin, Louisiana. His son has taken to shrimping, too, adding a fourth generation. In the off-season, Kenneth builds shrimp boats. He says you don't get rich shrimping, but it is in his nature.

He describes the process like this: "Well, you go out there and you find shrimp, and you catch them, clean them, ice them, and you just do that all day and all night long. You come in and you unload them and you get ready and you do it again."

WHEN I THINK OF PEACE, it's everybody getting along and working together and just helping each other out. When people are in trouble, you help them. When people need something, you help them and vice versa. You do it for people, people do it for you.

We started off with nothing and just worked our way up. In today's world, the kids want things right away. They don't want to live in a rundown trailer, they want to live in a brick house or have a new car. We never started like that.

Oh my god, we were poor. My dad had nothing, but we always had food on the table because that's how Cajuns are. We all have something to eat. We started from scratch, started small, and just worked our way big. People buy something they can't afford now. In them days, we didn't do that.

We Cajun, I don't care who come down here, you're welcome in my house. We always cooking and before I know it, I got a full table and we've got to put another table out. It doesn't

matter if it's people I know or don't know, it's just what happens. At one time everybody knew everybody and everybody just take care of everybody. It doesn't matter if I agree or disagree with the guy, if he needs help, I'm going to help him. It's just the way it is.

When I was a kid growing up, we didn't have air conditioning. Our doors were open, our windows were open, we had attic fans and cool air blowing in the house. You could walk in somebody's house and that didn't mean nothing. Nothing happened. In today's world, my doors are locked. Every little noise you hear, you wonder if somebody is coming in your house. Society is changing. Nobody knows nobody. You don't know who is next door.

I'm not saying it's good or bad, but I've got a .357 in my room and I tell my kids not to come in my house unless they call.

They got people who do good for people, you don't ever see that on the television. They show what they want to show. They show what you want to see. I think that affects your mind, it makes you think different. It makes you on the offensive. It makes you watch your step. My mama didn't know where I was half the time when I was a kid, but I always came back home. It was a neighborhood.

I don't think people got time to socialize. They leave to go to work in the morning, they come back at night. They're tired, and I'm telling you, I get tired too, I don't want to go running around. Back in the days, everybody used to sit on the porch, they gossip, and everybody knew what was going on. I want you to ride around and tell me how many people you see sitting on the porch talking to each other. You don't see it.

When I was a kid, we had a ball in our hand. We got in trouble sometimes. We did stupid stuff, but we had a baseball in our hand and we had a bat. My mom would chew me out for not doing my homework because I went and play baseball.

You ride around and you tell me how many people are playing baseball or football and basketball. You don't see it. You see video games. Maybe that benefits them if they're going to work computers later on. I got a 2-year-old grandkid that knows how to play a computer. I don't know how to play a computer. It makes him smarter. I don't know if it makes him better.

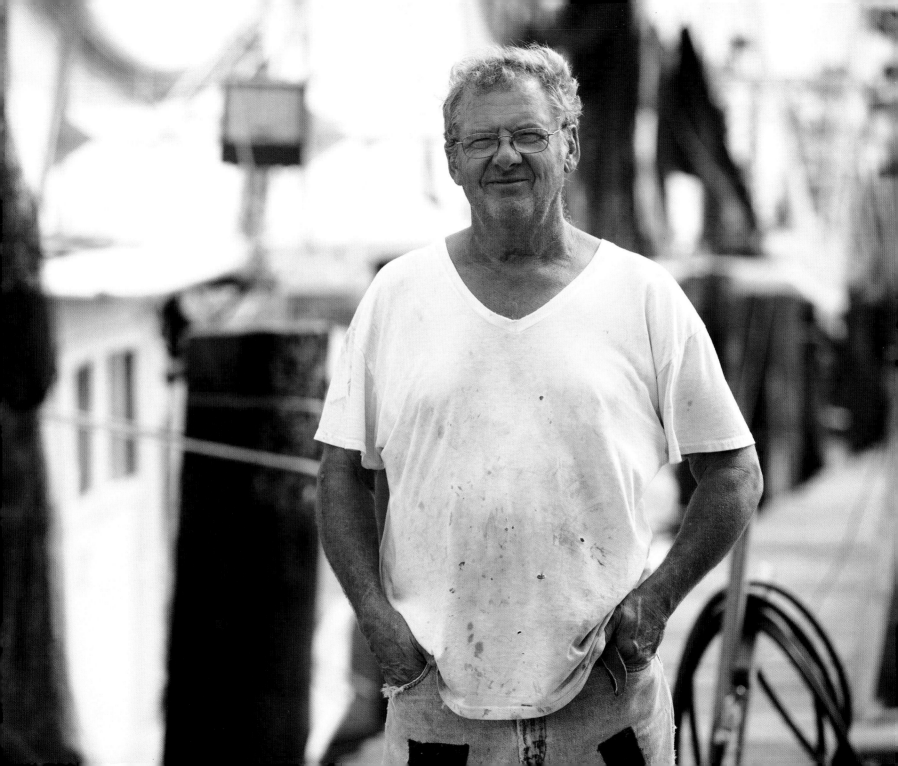

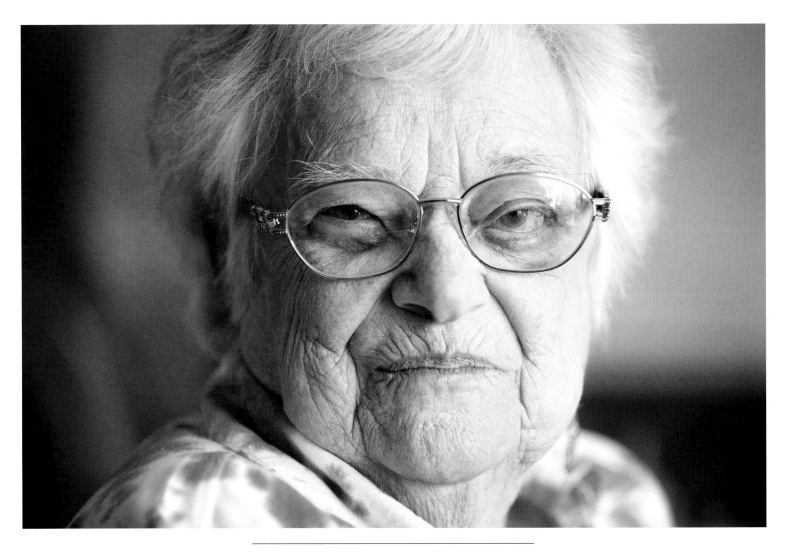

"*Interestingly I did not develop a hate.*
I don't hate anybody, I feel that
hate is a very powerful thing. It destroys yourself
instead of other people."

Penina Bowman was 17 years old when soldiers showed up at her home in Hungary and told her family they had 20 minutes to pack their bags. They were told they were being sent away to work, but the train brought them to Auschwitz.

Penina lost her parents and 42 other relatives to the Holocaust, but she and her three siblings survived. She credits her sisters and her faith for her survival.

WHEN WE ARRIVED at Auschwitz, we didn't know where we were. Everything happened so fast. We got off the train, and the soldiers were separating women on one side and men on the other side, able bodied to one side. It's almost impossible to explain the fear that you have every day, not knowing what's going to happen. You never forget being hungry. You talk about it all the time. You dream about it. You treasure that little piece of bread you have, so that nobody else will take it away.

My two sisters and I stuck together and that's what helped us survive. When one of us was down, we would encourage each other. We prayed. Psychologically, I think prayer helps. I didn't lose my faith and I didn't lose my sanity. Having something to believe in helped us survive.

I refused to eat when I first got to Auschwitz. I wouldn't touch the food because it wasn't kosher. My sister didn't know what to do because it looked like I was killing myself. She tried to talk me into eating and it didn't work. Then she found one of our aunts who was in Auschwitz for a short time—she disappeared after a while—and she told me that it's a bigger sin to commit suicide than to eat non-kosher food. So she took the food and pushed it into my mouth.

When I first came to the United States, I saw so many of my fellow Holocaust survivors who were destroying themselves because of their hate. They couldn't enjoy life, they couldn't go on with their lives, and I said, "this is not going to happen to me." I don't hate anybody. Hate is very powerful. It destroys yourself instead of destroying other people.

I would not wish war on anybody. People don't realize what it means to live with guns and soldiers and the fear that you're going to be killed any minute. And the worst part is that people don't appreciate what they have.

Because of what I went through, I learned to appreciate everything and not make a big deal out of things. My mother-in-law lived with me for 28 years after she became a widow, and we never had an argument. I would tell her, "Don't iron my things," and she would iron my blouse and burn the collar. OK, so it wasn't a big deal. Or she would break a china cup. It didn't matter.

People don't realize how lucky they are, so they make a big deal out of small things. I don't worry about little things. I let them be.

PENINA BOWMAN
**ATLANTA
GEORGIA**

LEROY SULLIVAN
**DONALDSONVILLE
LOUISIANA**

*"If we just dare
to help one another,
to love one another,
to treat one another
with the utmost
respect, this world,
this country would
be a better place
to live."*

Leroy Sullivan has been the mayor of Donaldsonville, Louisiana, since March 2004. Prior to serving as mayor, Leroy worked at a local chemical plant and was burned over 50 percent of his body in an explosion at the plant. He spent 37 days in a burn unit.

Donaldsonville has a population of 7,436, but it has the same struggles as larger cities: poverty, drug abuse, violence, and murder. The community has come together to try to move forward, but our memories are short, says Leroy, and we need to learn the same lessons over and over again.

PEOPLE WHO ARE LIVING in poverty are looking for a way out. So young boys, young girls start selling drugs and the drugs lead to violence. Not having a good education and not being able to get a decent job increases the chances that you're going to turn to something illegal. And then you end up incarcerated. It all works hand in hand.

When I was a young boy growing up in Donaldsonville, if I did something wrong, the neighbors were there to correct me. Let's say that I walk into the neighborhood store. Every time I passed by an elderly person, I had to speak. Don't matter if I passed them ten times. I was going to speak. And if you didn't speak, you know your parents are going to find out about it. You speak going, you speak coming back. You respect the people in the community because it was such a close-knit community.

We grew up respecting those in the community. You don't have that now. A lot of the young people don't respect their parents. They don't respect their teachers. They don't respect me as the mayor. That's what we have to work on. You won't have true peace until we take back control of this nation. And the only way that you're going to do that is by letting people know love. Sometimes it's tough love. If you don't do what I tell you to do, there are consequences. Because if not now, eventually, when they're old enough, they're behind bars.

We have problems in the school system because when the teachers contact the parent about a problem in the classroom, the parent wants to go and attack the teacher. Until we change that [attitude], there won't be peace. Peace arrives from being able to have a good quality of life. The only way you're going to have a good quality of life is when our children learn values.

Yes, we say, if I had more money, if I had a better job, if I had this, if I had that, but what are we doing with what we have?

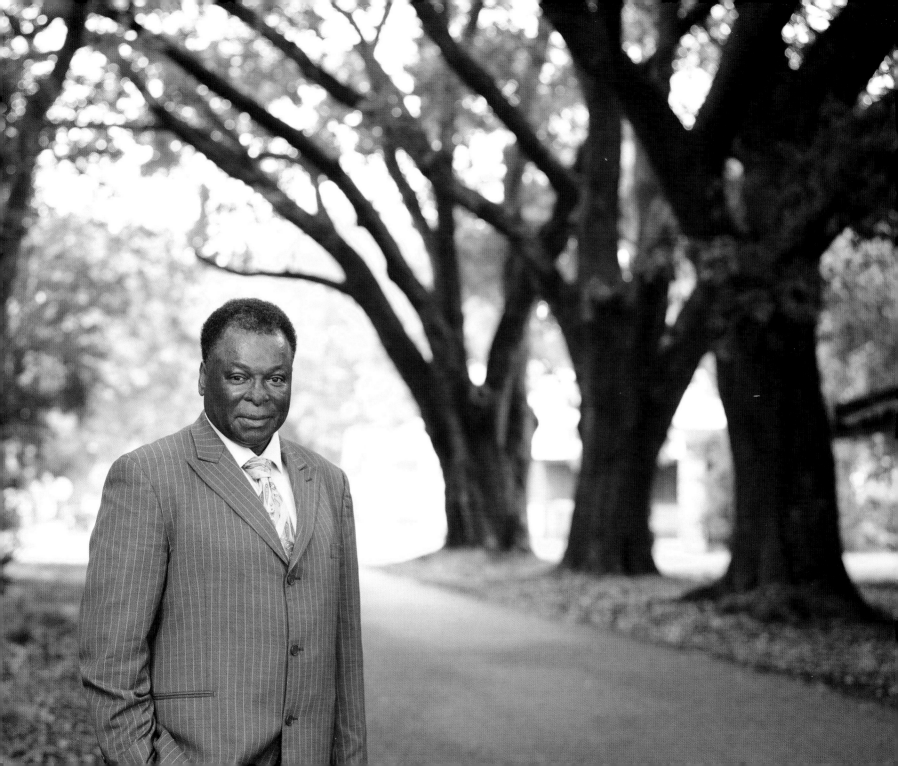

index

the atlantic states
p. 12

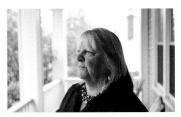
Hashim Garrett
14

Laura Patey
16

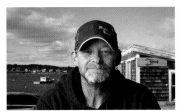
Chuck Rickter
18

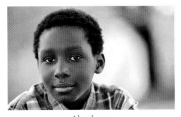
Alex Lowe
20

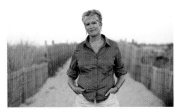
Kim Book
22

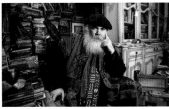
Matt Meyer
24

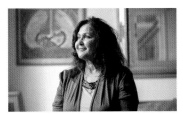
Talat Hamdani
26

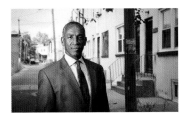
Tyrone Werts
28

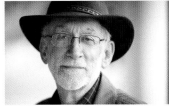
Howard Zehr
30

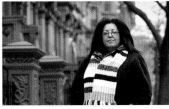
Yanina Calderone
32

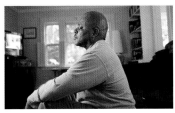
Donnie Phillips
34

the central states
36

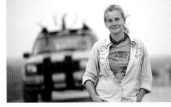
Erika Nelson
38

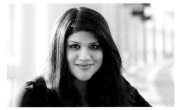
Maham Kahn
40

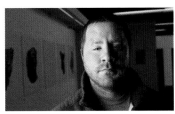
Phillip Schladweiler
42

Deanna Thompson
44

Gina Laff
46

Myron Pourier
48

Leah Prussia
50

Angela Bates
52

John George
54

Amy Robinson
56

Eric Menzel
58

the west
60

Cesar
62

Dan Gallagher
64

Betsy Dague-Mulligan
66

Michael Reid
68

Jimmy Ta
70

Andrea Cano
72

Brandon Sheehan
74

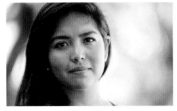
Julissa Arce
76

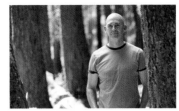
Chris Brixey
78

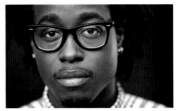
Rashaad Arnold
80

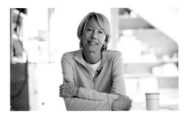
Peg Carlson
82

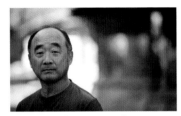
Clarence Moriwaki
84

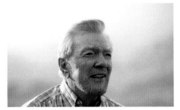
Ray Padre Johnson
86

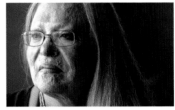
Benita Alioth
88

the southwest
90

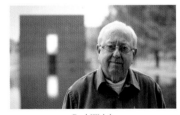
Bud Welch
92

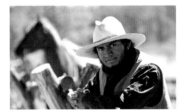
Hassan Ikhzaan Saleem
94

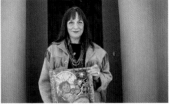
Amy Cordova
96

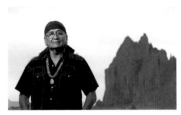
Eugene Joe
98

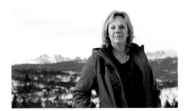
Heather Ehle
100

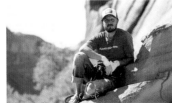
Taylor Bond
102

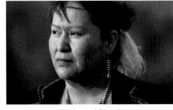
Sheila Goldtooth
104

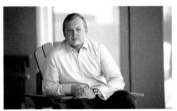
Brett Menzie
106

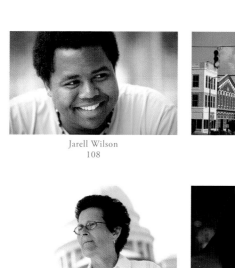

Jarell Wilson
108

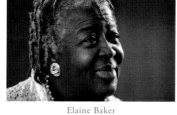

the south
110

Joanne Bland
112

Fiona Orr
114

Kathy Webb
116

Carl Kenny
118

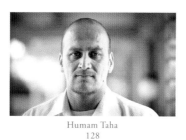

Donna Watts
120

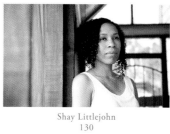

Tony Thomas
122

Claudia Horwitz
124

Elaine Baker
126

Humam Taha
128

Shay Littlejohn
130

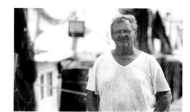

Kenneth Theriot
132

Penina Bowman
134

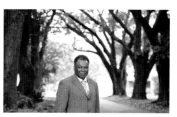

Leroy Sullivan
136

discussion questions

A PEACE OF MY MIND is built on the practice of listening. There is wisdom and hope in the stories found in this book. In fact, these kinds of stories exist all around us, if we take time to listen.

This collection of stories can serve as a catalyst for rich dialog and new understanding about ourselves and others. Consider exploring the questions below on your own, or with a group, as a way to continue the conversations started in this book.

Many of the questions are the same ones I used during the interviews. Others are rooted in simple human curiosity. Enter into these conversations willing to share your own experience, but with the goal of learning from others. Together, we can lead the public conversation toward peace.

[1] What does peace mean to you?

[2] When have you seen a great example of peace?

[3] When have you gone outside of your comfort zone to understand others?

[4] When have you acted on your highest ideals?

[5] When have you fallen short and disappointed yourself or others?

[6] When has someone forgiven you? Shown you grace?

[7] When have you offered forgiveness and grace to others?

[8] What gives you hope?

[9] Which story in this book resonated with you? Why?

[10] Which story challenged you? Why?

[11] Which story surprised you? Why?

[12] When have people misunderstood you? How did that impact you?

[13] When have you misjudged another?

[14] What is your greatest blind spot?

[15] How will you commit to overcoming it?

about this book

I AM GRATEFUL for all the people who shared their stories to make this book possible. I have come to see myself as a curator of stories. It has been a gift to cross paths with each one of these people, and I have been touched by their willingness to open their lives to me. I hope they feel some sense of pride in lending their voice to this collection.

This book's design and layout are the result of long-time friend and designer Barbara Koster who takes my vague notions and makes them a reality on the page. Her attention to detail is unmatched, and we all are the beneficiaries.

A Peace of My Mind: American Stories has been edited by another long-time friend and colleague, Teresa Scalzo who reminds me to keep sight of the larger vision while examining each individual word for meaning and clarity.

My wife Karen, our son Jordan, and our daughter Brenna have been patient, kind and supportive throughout this entire process, believing in the project and encouraging my work when I've been slowed by doubts and frustrations. In a world of uncertainty, they remain my constant source of courage. I hope this project will teach them to persevere in their own efforts.

There are more people than I can mention who have offered kind words, encouragement, insight, and support in the process of creating this book. After a year of pursuing publishers and agents, we kept hearing the same answer; "This is a great concept, with beautiful photos and engaging text. . . but we don't think we will make enough money off of it, so good luck." So we ran an Indiegogo campaign. More than 100 people stepped forward and offered financial backing to support our effort. The names listed to the right deserve special gratitude for contributing substantially to the production of this book.

Together, we can do big things.

With peace and gratitude,
John Noltner

CONTRIBUTORS

Sandra & George Anderson

Paul & Melinda Batz

Verla Bayard

In memory of Baby Blake Bohnsack

Traci & Dan Brandt

Marie & John Braun

Deb & Gene Cross

Ericson Family

Jon & Betty Hansen

Tammy Hanson

Todd & Julie Hanson

Jeannette Rankin Peace Center

Cheri Johnson

Diane Kohrs

Barbara & Brian Koster

Jason Krumm

Karen & Rick Larkin

Andrea N. LeBlanc

Jason Lindsey

Phil & Karen Luck

Catherine Mamer

John & Kate Martin

Jennifer McNally

Jane Metcalfe

Donna & Michael Meyer

Bonnie & Rick Mickelson

David & Annette Murphy

Erika Nelson

New England Kurn Hattin Homes

Gordon & Betty Olson

Meg Ovikian

Steve & Kim Phillips

Mark & Janet Pladson

Joan Posch

William Repicci

Joan Roisum

In memory of Nate Schwanz

Zafar Siddiqui

Bob & Kathy Simmons

Kent & Juli Wunder Simmons

Naomi & Steve Staruch

Denise & David Thoen

Jim & Lori Thomson

Flora & Dean Tsukayama

Onder Uluyol

Eileen & Larry Winsand

Kay & Howard Witherspoon

Marj Wunder

Barry Yeoman